WOLVERHAMPTON
THROUGH TIME
Alec Brew

AMBERLEY

First published 2019

Amberley Publishing
The Hill, Stroud, Gloucestershire, GL5 4EP
www.amberley-books.com

Copyright © Alec Brew, 2019

The right of Alec Brew to be identified as the
Author of this work has been asserted in accordance with
the Copyrights, Designs and Patents Act 1988.

ISBN 978 1 4456 8790 2 (print)
ISBN 978 1 4456 8791 9 (ebook)

British Library Cataloguing in Publication Data.
A catalogue record for this book is available from the
British Library.

Origination by Amberley Publishing.
Printed in Great Britain.

Introduction

Any long-term resident of Wolverhampton will know how much the city has altered over the years – not least changing from a town to a city. In 1848 it had been incorporated as a borough, and had already begun a massive transformation from a market town to an industrial centre. Coal workings on the south side of the town and the growth of metal bashing and a host of new industries sucked in people from the countryside and led to rapid expansion, symbolised by the building of 'Newhampton' in the area of Whitmore Reans.

By the start of the twentieth century most of the significant civic buildings were there – the Town Hall, the Art Gallery, the Central Library – and a new electric tram system was just about to begin. High- and low-level stations, East and West parks, the two shopping arcades, Beatties, Molineux House and Stadium, and the ancient road network were all little changed through the first half of the new century, even by the Luftwaffe. Then came the 1960s.

The planners set out to 'modernise' the town, and concrete was their preferred medium. The Mander shopping centre did away with the Central and Queen's arcades, the Wholesale and Retail markets were flattened as the council eyed the space for their new Civic Centre, and then the ring road cut a swathe all around the town centre. In many cases it is very difficult to relate old photographs to the townscape existing today.

This was a problem I expected when setting out to take modern photographs from the same places as the old ones I had gathered. What I did not expect was how verdant Wolverhampton has become. Time and again I found it impossible to take a photograph from the same spot as the early twentieth-century photographers because there were too many trees in the way. This may have been a direct result of the council's plan to plant a thousand trees after the First World War to commemorate the fallen, or it may be just a sign of the maturing of the town.

Another huge change to the townscape has been the disappearance of many of the large companies that dominated their neighbourhoods. The buildings of some, like Sunbeam and more recently Butler's Brewery, still stand and have found new uses; others, like Bayliss Jones and Bayliss, ECC, Courtaulds, GWR's Stafford Road Works, AJS and just recently Goodyear's, have been demolished and replaced with something else.

If the ring road was the biggest destructive influence on the townscape, then the university has been the biggest positive influence of late: old buildings have been given new uses, many new buildings have been built, and over 20,000 students are educated and are in need of accommodation and entertainment, which gives a great boost to the housing and leisure industries.

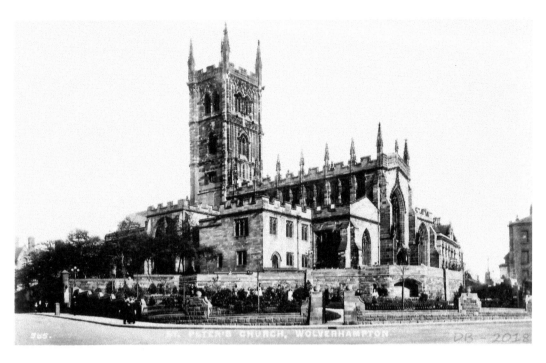

St Peter's Church from the Marketplace

The focal point of Wolverhampton for many centuries has been St Peter's Church. With a dominant position on top of the ridge on which the town is built, the council have happily prevented any taller buildings encroaching upon it. Shown above in 1902 in a picture postcard taken from the front of the Wholesale Market, it can be seen in all its glory. Nowadays, as seen below, trees have grown to obscure much of it and the Civic Centre encroaches on the right.

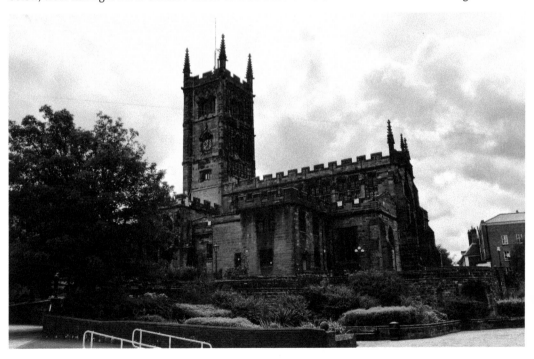

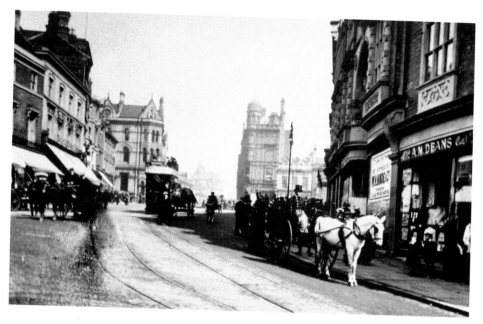

Queen Square from Victoria Street

Though this 1904 photograph is immediately recognisable as Queen Square, close examination reveals just how different the central hub of Wolverhampton now is. The building at the centre, on the corner of Lichfield Street (now the HSBC Bank), is much reduced in height, having lost its tower and then later the top storey; Barclays Bank, however, on the other side of the road, is much as it was. The coachman in his top hat is waiting outside AM Deans ladies clothes shop, near the entrance to the Queen's Arcade, and the Lorain surface-contact system tram will soon come rattling by, down Victoria Street. This area is now the entrance to the Mander Centre, between KFC and New Look, and the modern picture is dominated by flower arrangements in the greatly increased pedestrianised area.

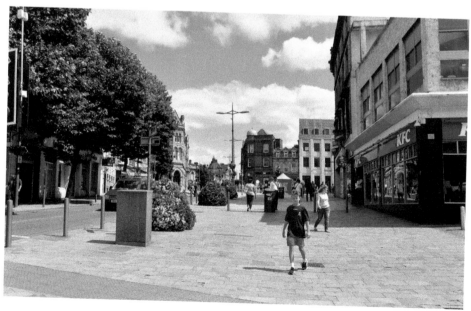

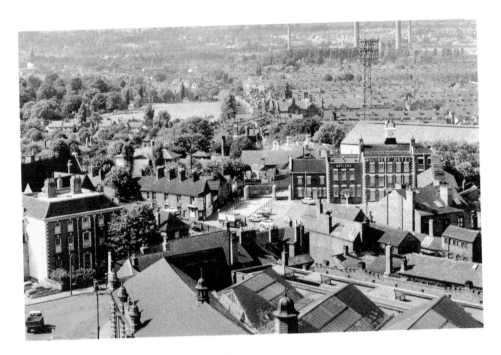

The Molineux from the Top of St Peter's

A 1940s picture taken from the roof of St Peter's over the top of the Wholesale Market's roof shows the Molineux Hotel on the other side of North Street (not yet cut by the ring road) and the roof of Molineux football stadium's South Bank, with one of the towering floodlight pylons. Beyond are the terraced streets of Whitmore Reans and the roof of the Municipal Grammar School. Beyond that are the Three Sisters, the chimneys of Courtauld's factory. The picture today shows the Civic Centre occupying the market patch as most of the old buildings were swept away, along with the Courtauld's factory in the background. Thankfully Molineux House survives as the City Archives with a large extension to the side, and the home of the Wolves has been redeveloped into the 'Golden Palace'.

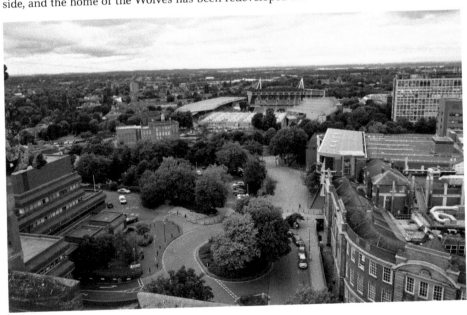

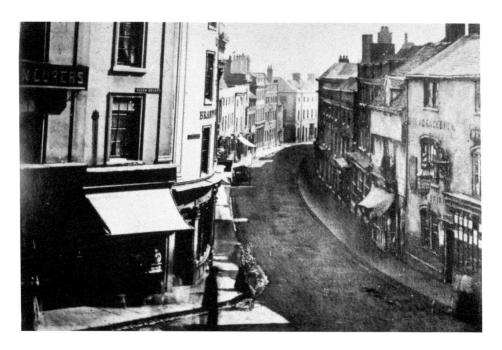

Victoria Street from Queen Square

Victoria Street in the late nineteenth century shows that all the buildings to the right, starting with the Spread Eagle, have gone and the street has been widened – most notably by Beatties' new building around 1929. The modern Victoria Street is dominated to the western side by Beatties' art deco frontage, and on the eastern side by various entrances to the Mander Centre. Beatties started as a shop on the eastern side, but after a fire relocated over the road and expanded greatly, buying up properties along Victoria Street and Darlington Street. The clock celebrates the firm's 100th anniversary.

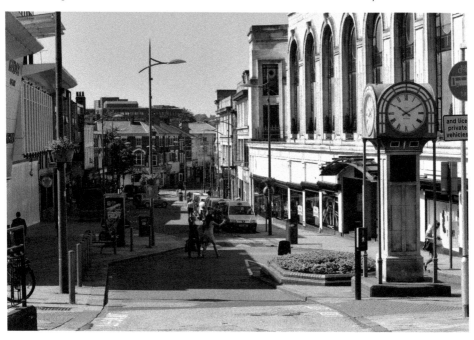

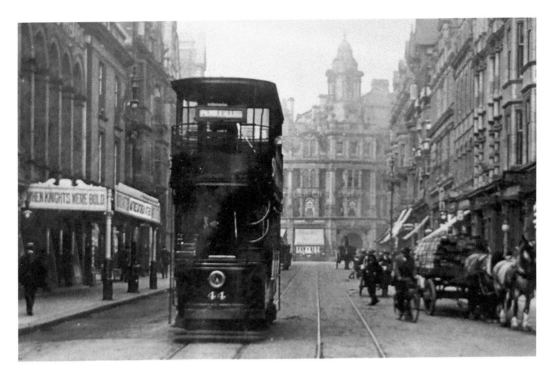

Lichfield Street

A Lorain system electric tram passes the Grand Theatre in Lichfield Street, where *When Knights are Bold* was playing. The modern electric/hybrid bus is on the same spot, and *The Jersey Boys* is on at the Grand. The buildings on the other side of the road were demolished to build the white, art deco Co-op department store, which closed fifty years later and now houses The Moon Under Water pub. The Royal London building in the background remains the same.

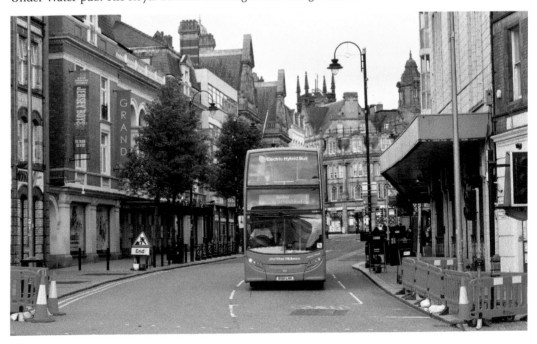

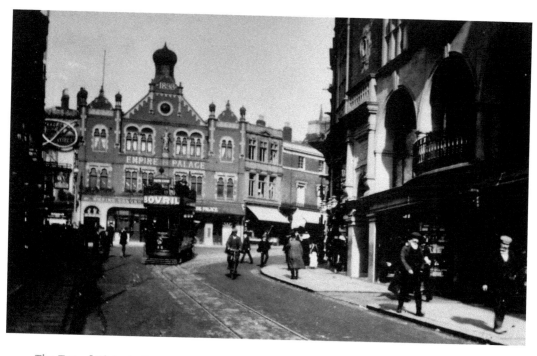

The Top of Victoria Street

A view up Victoria Street showing the Empire Palace Theatre at the bottom of Queen Square. The Empire Palace opened in 1898, but became the Hippodrome in 1921. That was destroyed by fire in 1956 and the present building replaced it, firstly as Times Furnishing and now Yates. The Lorain system open-topped tram is entering Queen Square. The modern scene is dominated by the corner of the Mander Centre, to the right.

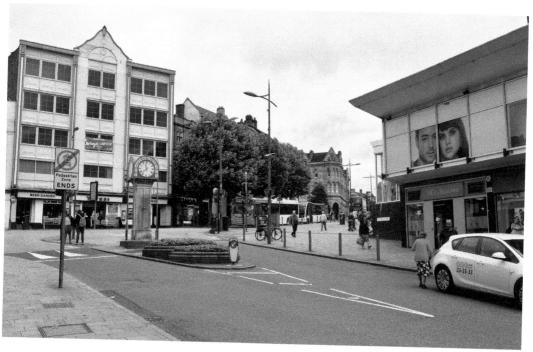

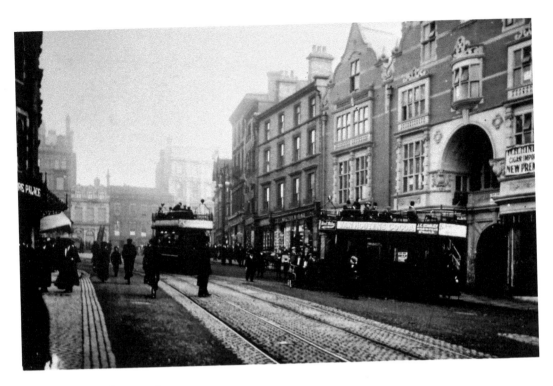

The West Side of Queen Square

A photo across the bottom of Queen Square taken around 1905 with two trams, one stopped outside the entrance to the Queen's Arcade. The arcade, a much-missed building, was replaced by the concrete entrance to the Mander Centre, though the next buildings on that side are still much the same. Mander House now dominates the background.

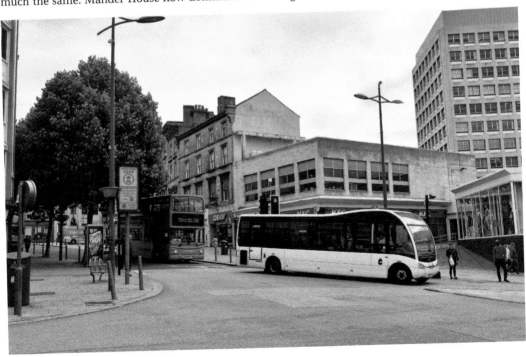

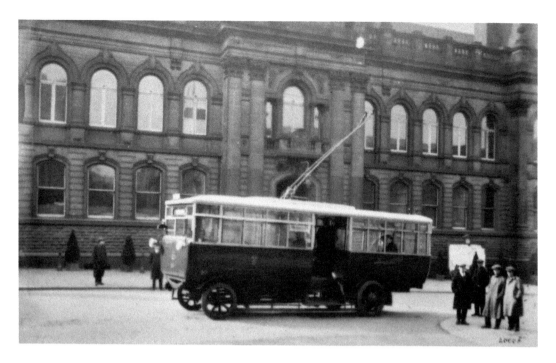

The Town Hall

The Town Hall in the 1920s with a Tilling-Stevens TS6 single-deck trolleybus passing by. They were the first of the town's trolleybuses. A total of thirty-two of them were purchased to replace the worn-out trams, which were used until 1937, often on routes with low bridges where double-deckers couldn't go. Today the building is the Magistrates' Court, seen without public transport passing by as North Street has now been cut in two by the ring road.

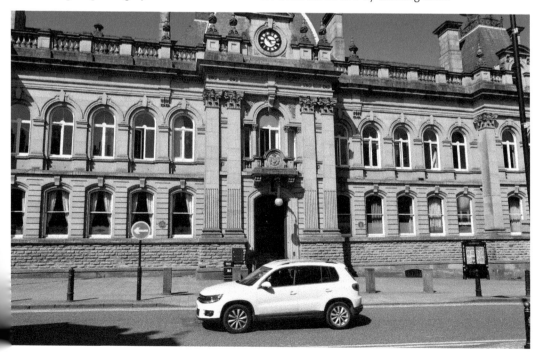

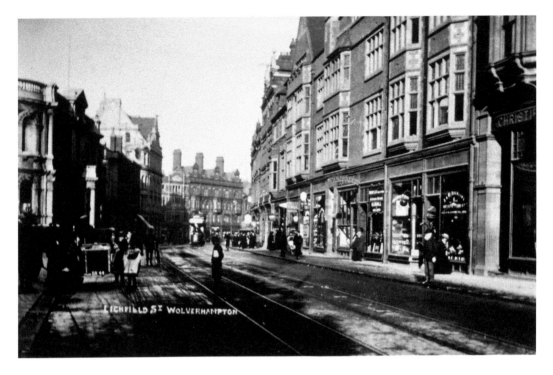

Lichfield Street

Lichfield Street from the eastern side of the road, showing the trams tracks with a tram approaching from Prince's Square and a very early number plate – DA44 – on the solitary vehicle. Apart from the trees and the benches, this scene is pretty much the same, with all the buildings still remaining today.

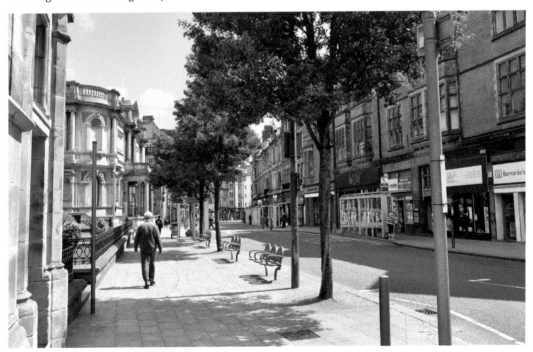

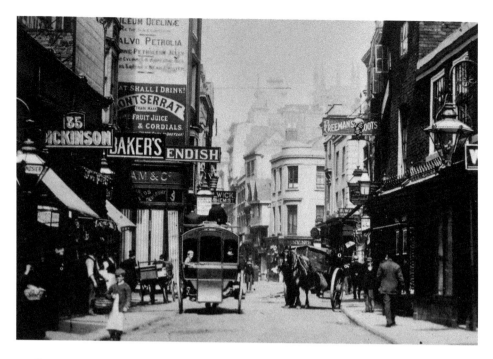

Dudley Street

The middle part of Dudley Street with St Peter's just visible in the background. Only horse-drawn vehicles are in use. Most of these buildings have now been replaced, though the fine five-storey building at the end of Woolpack Street (to the left) is just visible. It is now pedestrianised, with the exception of delivery vehicles – though, in truth, vehicles were always largely ignored in Dudley Street and drivers had to go slowly and take care as shoppers wandered over the road.

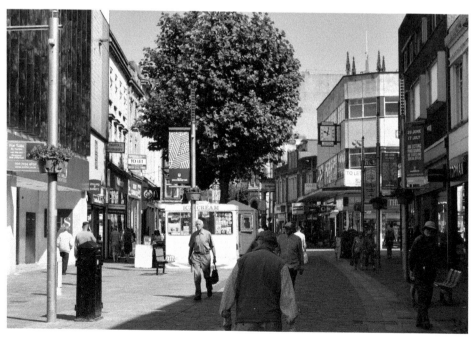

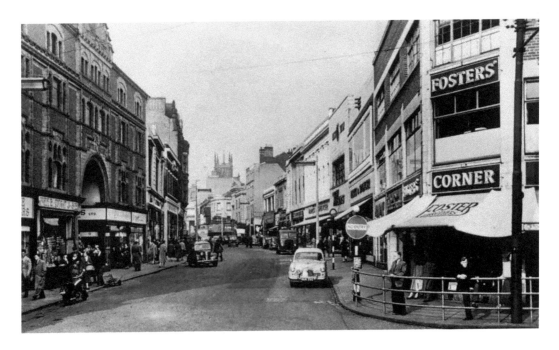

Dudley Street

The lower part of Dudley Street in the 1950s, with the entrance to the fine Central Arcade to the left and Fosters' menswear on the corner of Bilston Street. Marks & Spencer's were well established on the right-hand side, with Woolworths and the British Home Stores opposite. The same scene today shows the entrance to the Mander Centre replacing the Central Arcade. M&S still remains, but opposite both Woolworths and BHS have closed. River Island occupies the former Fosters' shop.

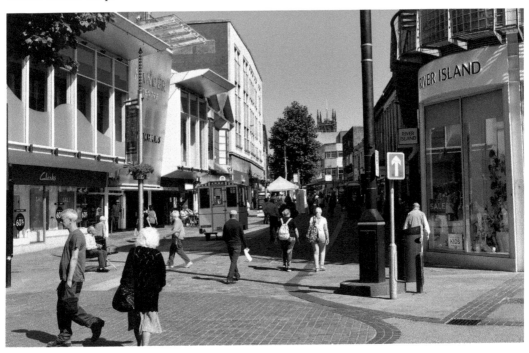

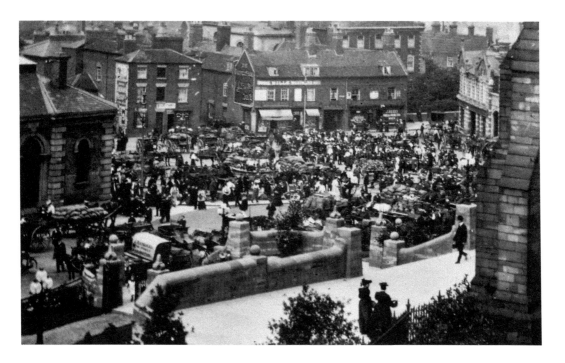

The Old Marketplace

The bustling outdoor market photographed from by the door of St Peter's, with the indoor Retail Market to the left and the Wholesale Market to the right. In the background shops line North Street with Giffard House and the Catholic Chapel hidden behind them. Nowadays the whole site has been appropriated for the brick monolith of the Civic Centre, and the statue of Lady Wulfruna on the steps of St Peter's looks out on a scene she would not recognise.

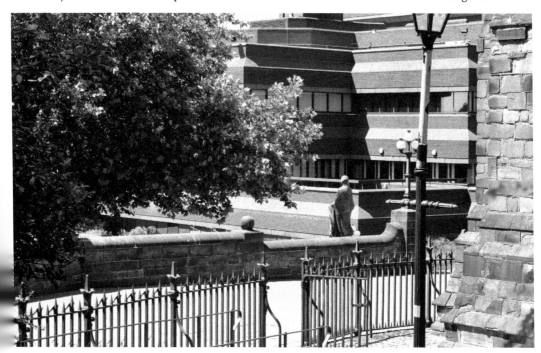

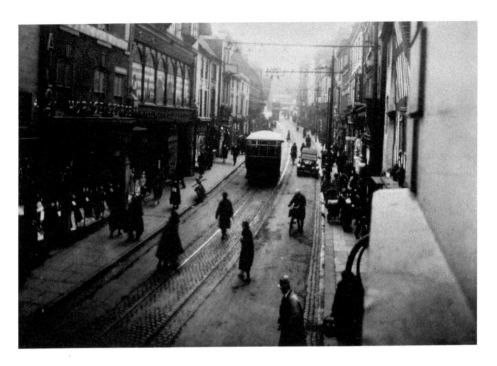

Lower Victoria Street

A single-decker motor bus makes its way up Victoria Street, with a double-decker tram near the top. All the buildings to the left were knocked down and the road widened. Lindy Lou's, which dates from the first half of the seventeenth century, is just visible to the right in both photographs on the corner of John's Lane, now much abbreviated by the Mander Centre. Because it is wider, the modern photograph makes the street look shorter, and Yates nearer than the Hippodrome in the old photograph.

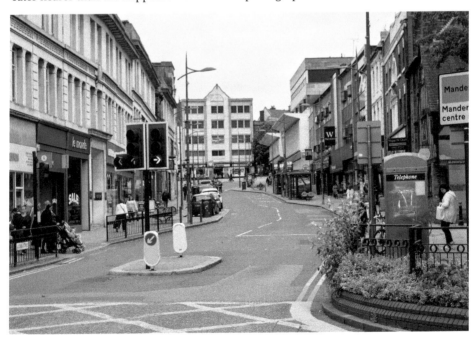

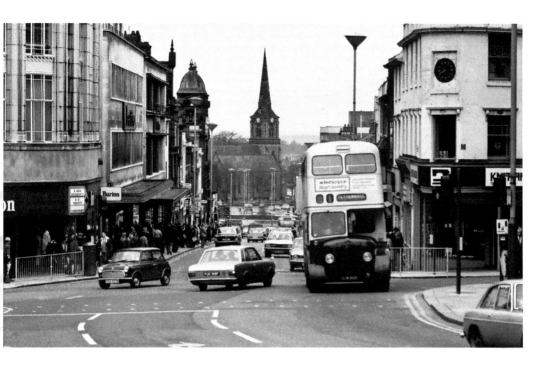

Darlington Street

A view down Darlington Street early in 1970. Wolverhampton's Corporation Transport Department had closed in October 1969, and the fleet absorbed by the West Midlands Passenger Transport Executive – hence the Birmingham colours on the Guy Arab bus on the No. 1 Tettenhall route. Burton's the tailors still occupied the Victoria Street corner and, as can be seen, this was still a crossroads, open to private vehicles in all four directions. Nowadays most of the buildings still remain, though Beatties have taken over the Burton store.

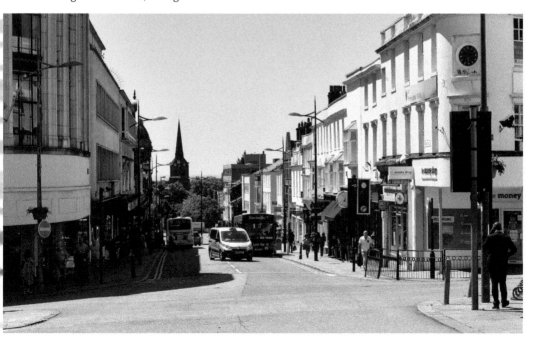

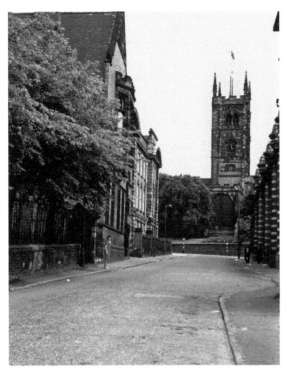

St Peter's Square

St Peter's Square, with the church in the background, the Wholesale Market to the right and the Wolverhampton – Staffordshire Technical College to the left. The road that used to be Horsefair, then Wulfruna Street, has now been abbreviated and the Wholesale Market demolished, as was St Peter's Church Hall and School just around the corner, to make way for extensions to what is now Wolverhampton University.

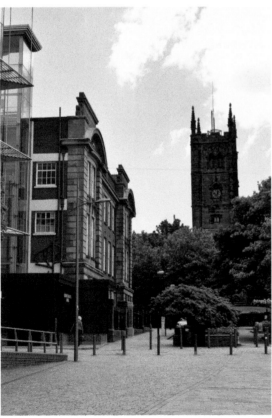

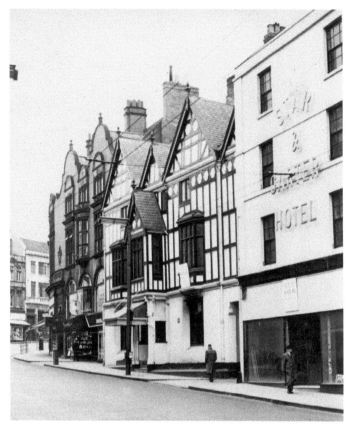

The Star and Garter Hotel
The Star and Garter Hotel at the top of Victoria Street occupied the site of a house where Charles I sheltered during the Civil War, but this was rebuilt in 1836. It became the town's foremost hotel, but closed in 1961 and was demolished three years later to make way for a new entrance to the Mander shopping centre, which was built to the rear of the buildings on Victoria Street and Dudley Street. The new photograph shows the newly remodelled Mander Centre entrance.

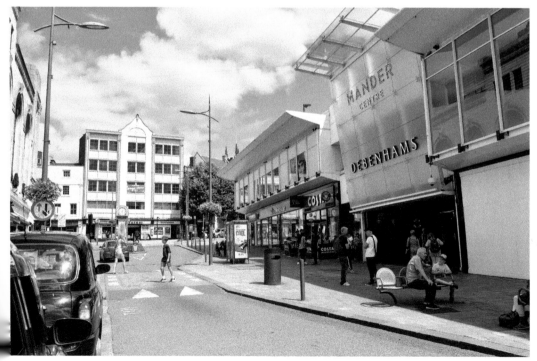

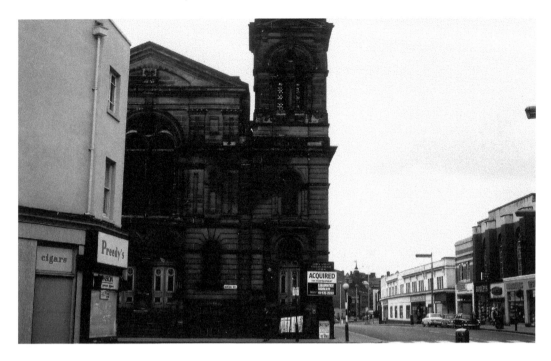

The Congregational Church

The Congregational Church on the corner of Queen Street and Princess Street was built in 1864 to replace an earlier smaller building. The long side was on Princess Street with the steeple on the corner. As can be seen in this 1960s picture, the church was then closed and put up for sale. It was demolished and the Job Centre was built on the same spot. Happily, most of the other buildings that can be seen along Princess Street are still there, and the street has been repaved.

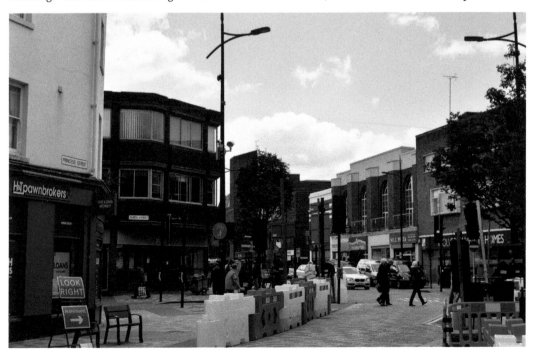

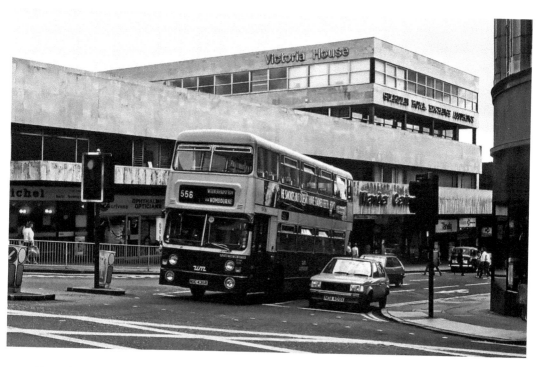

Victoria Street/Darlington Street Junction

The top of Victoria Street in the 1970s as a No. 556 bus turns into Queen Square, with the brutalist Mander Centre behind. The modern scene was taken after a makeover has tried to mask the 1960s architecture, giving it a new look, which also happens to be the name of the shop that replaced the Wimpy Bar on the corner.

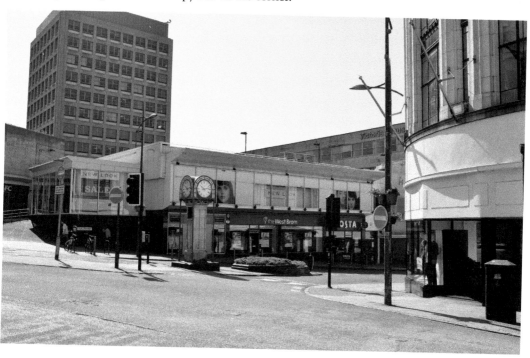

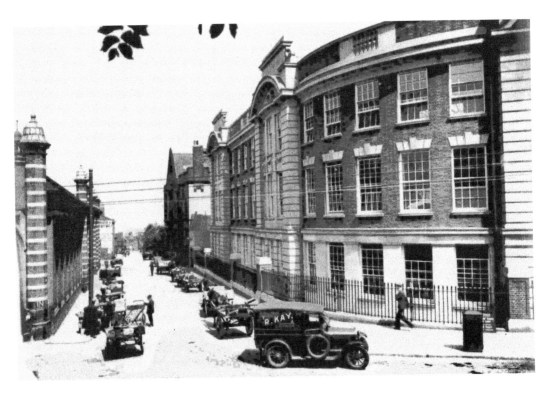

St Peter's Square and College

Wulfruna Street, between the Wholesale Market and the Wolverhampton and Staffordshire Technical College to the right, with St Peter's School beyond. This street used to be called Horsefair and curved round to meet North Street. The street had now become a cul-de-sac because of the ring road and Wolverhampton University, which occupies all the land to the right.

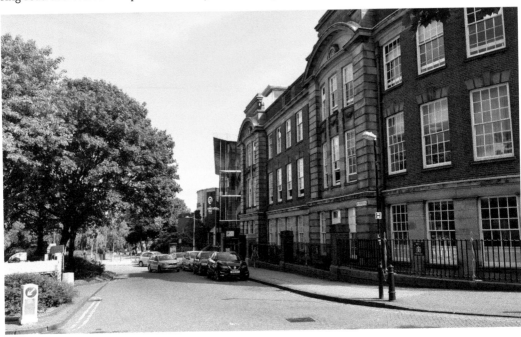

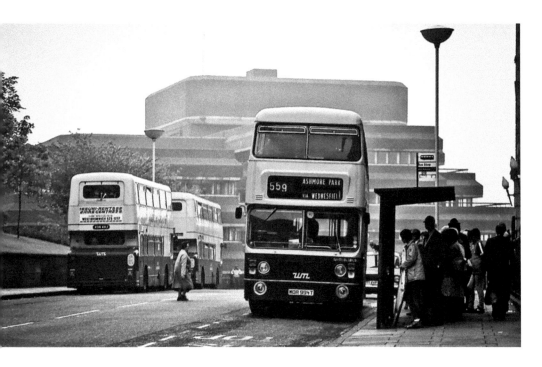

Wulfruna Street

The 1970s witnessed not only the town's buses turn from yellow and green to blue and cream, but the West Midlands Passenger Transport executive-imposed new three-digit route numbers, with Wolverhampton's largely in the 500 series – like these lined up at the stops, which were then located in Wulfruna Street. Nowadays the buses have been banished to the new bus station and the bunker-like Civic Centre is beginning to be hidden by trees.

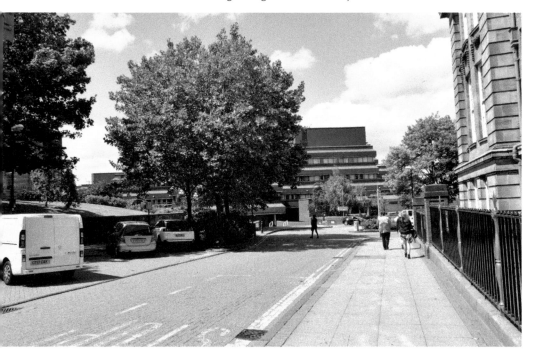

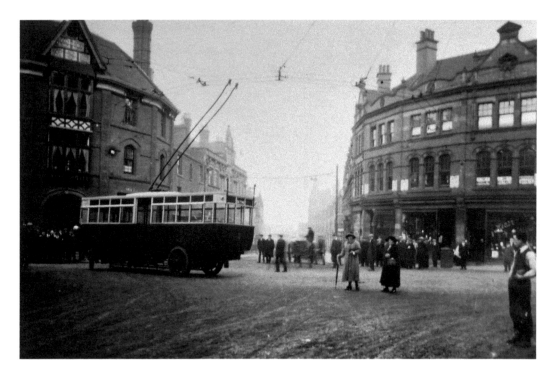

Broad Street

A Tilling Stevens TS6 trolleybus turns down Broad Street on its way to Wednesfield. Single-deckers had to be used on this route until the road under the railway bridge was lowered. All the buildings remain pretty much the same, just the street-level frontages have changed.

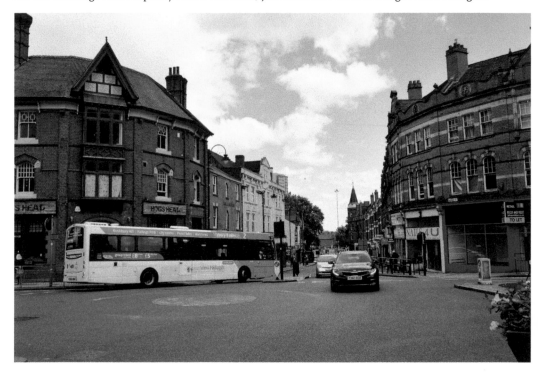

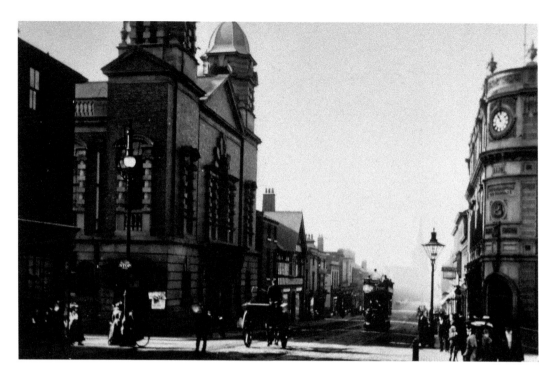

Darlington Street/Waterloo Road Junction

The lower part of Darlington Street was dominated by the Methodist Church, which was almost new when the photograph was taken, having been built in 1901. Appropriately, a large gas lamp stands outside what became the British Gas showrooms and offices. Nowadays the buildings below the church have gone, replaced by car parks, Crown House and the ring road traffic island. St Mark's Church in Chapel Ash still stands but is now offices.

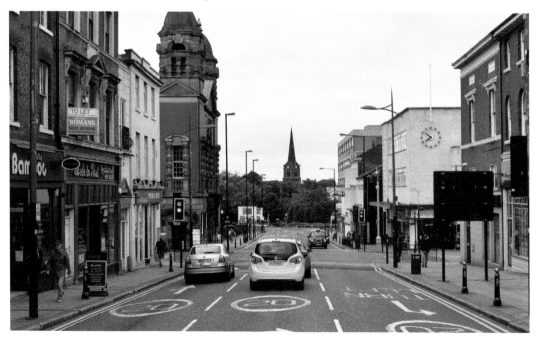

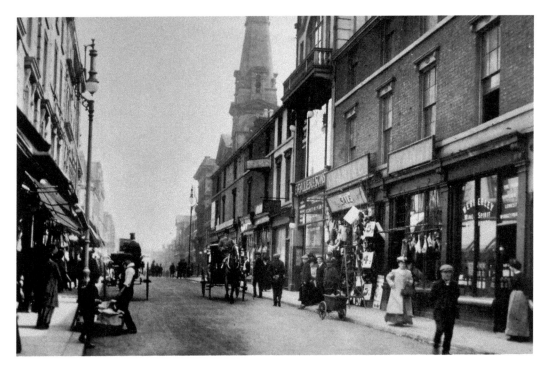

Queen Street

Queen Street looking towards the station from Dudley Street around 1900. The scene is almost unrecognisable today, not least because the Congregational Church is no longer there, but the buildings on both sides of this part of the street have now been replaced.

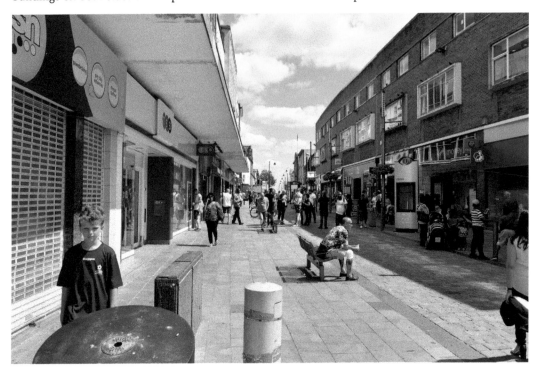

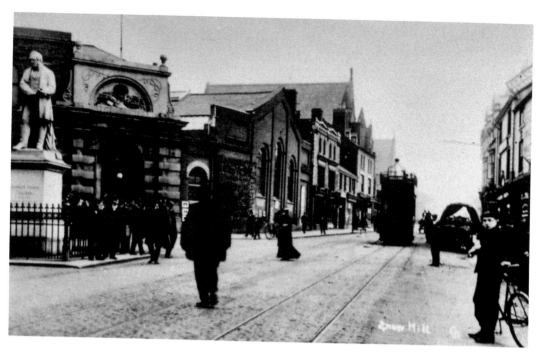

Snow Hill

The view up Snow Hill with the statue of Sir Charles Pelham Villiers (now in West Park). Behind him is the Agricultural Hall, later replaced by the Gaumont Cinema. The modern photograph shows the Wilko store on the site of the Gaumont and the entrance to the market opposite, which opened in July 2018 over the road.

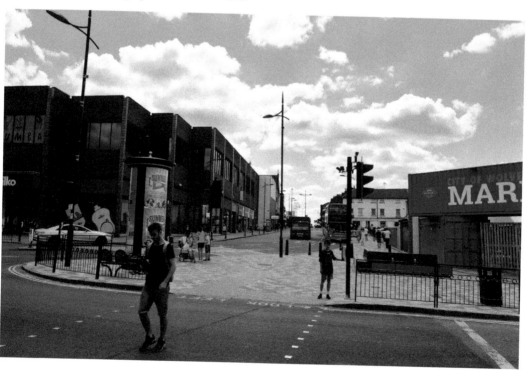

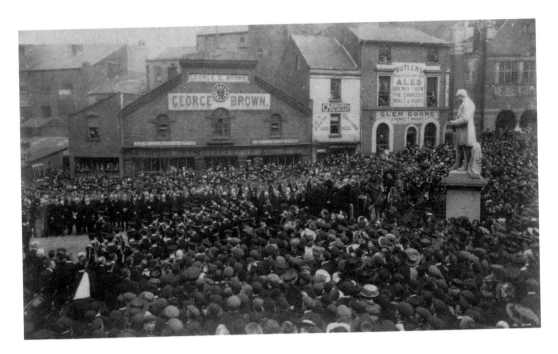

The Bottom of Snow Hill

The statue of Sir Charles Pelham Villiers, the town's longest serving MP, overlooking the proclamation of George V on 10 May 1910 at the bottom of Snow Hill. The Central Library, then eight years old, is to the right. Today the statue is in West Park. The George Brown's Agricultural store and the adjacent buildings were demolished to make way for the Wulfrun Shopping Centre. The entrance to the market is to the left.

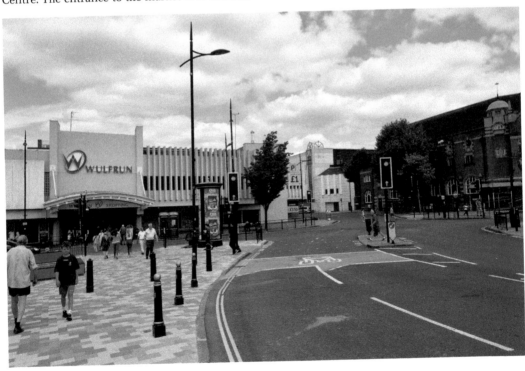

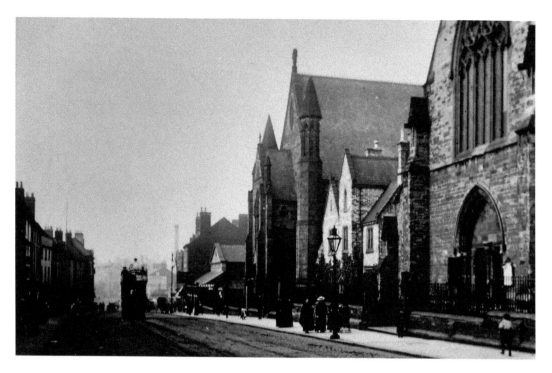

Churches on Snow Hill

A Lorain tram descends Snow Hill after passing St Mary's and St John's Catholic Church and the Congregational Church. The shops on the left still remain, at least above Temple Street. Everything in the distance and on the other side of the road has been replaced, apart from the Catholic church and Church House.

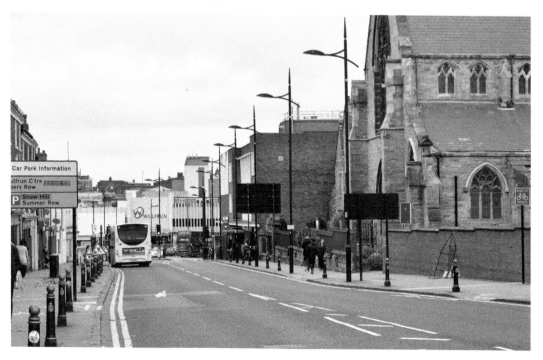

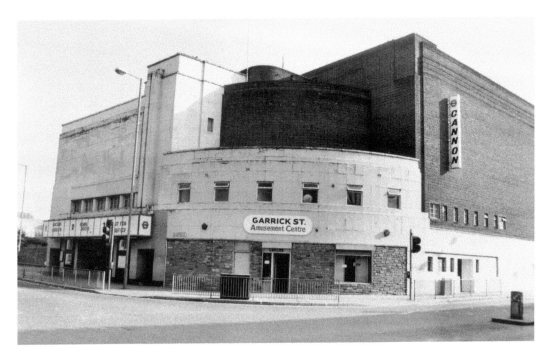

The Odeon Cinema

The former Savoy Cinema stood on the corner of Bilston Street and Garrick Street. It was later renamed the ABC, then the Cannon, and improved with three screens. The building was later converted to a nightclub, being reclad and going through different names. The amusement arcade on the corner has now become a Compton Hospice shop.

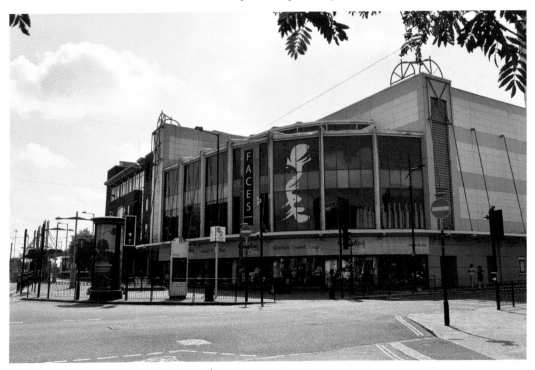

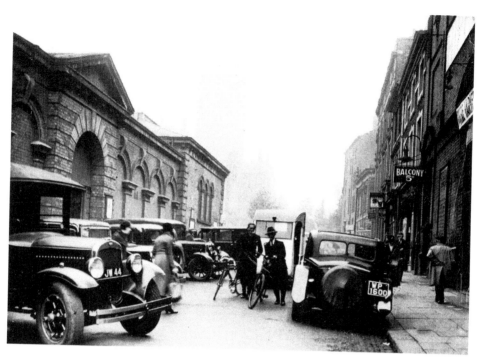

Cheapside

A view looking up Cheapside with St Peter's Church looming out of the mist in the background. The indoor market is to the left and the rear of the Hippodrome Theatre is to the right, now replaced by the Civic Centre and Yates respectively. Although you might expect there to be far less traffic in the past, this is not always the case: pedestrianisation, restricted access and one-way streets often mean fewer cars today.

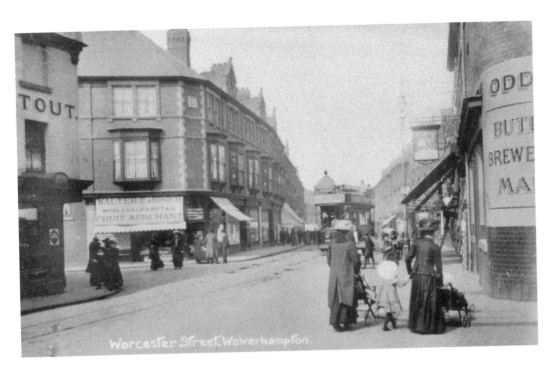

Worcester Street

Worcester Street during the first years of the twentieth century with the Oddfellows Pub to the right, one of the few buildings that no longer exists in this part of Worcester Street.

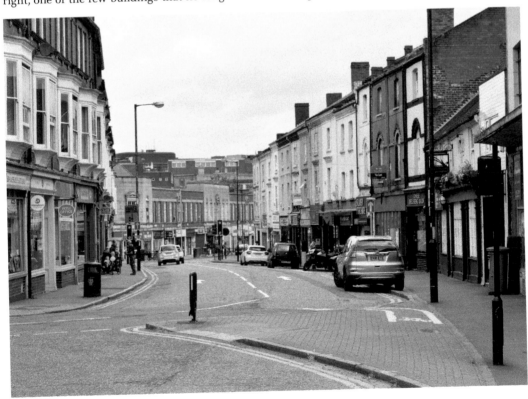

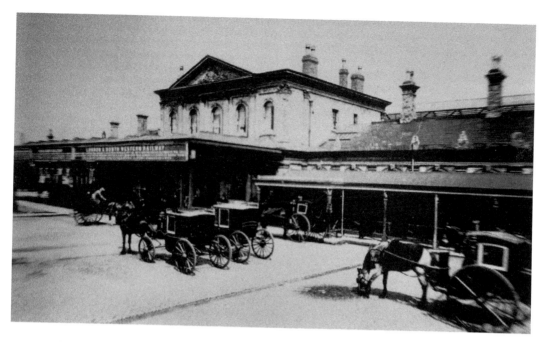

High-level Station

The London & North-Western Railway's High-level station opened in 1951 with a grand carriage access along Queen Street and through the Queen's Building, which lost its importance when the access road was realigned with Lichfield Street. The old station was not well-loved and was replaced with typical 1960s concrete. Even less loved is what is now Wolverhampton's only station, which is due for a rebuild. The student flats in Culwell Street now dominate the background.

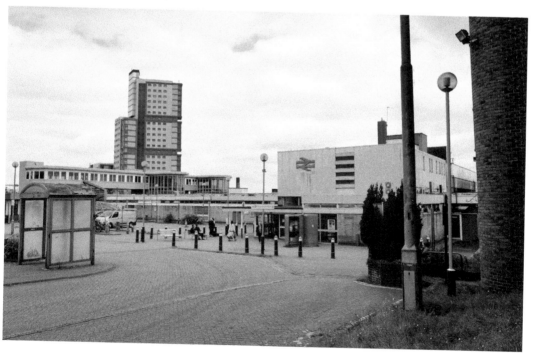

Railway Street from Railway Drive

This is one of those scenes from the 1960s that is hard to reconcile with the existing townscape. Only the fixed points of the Chubb Building, then in use by Baelz and the canal warehouse in Broad Street, help to orientate it. The ring road split the two nineteenth-century buildings, and a car park now occupies the foreground.

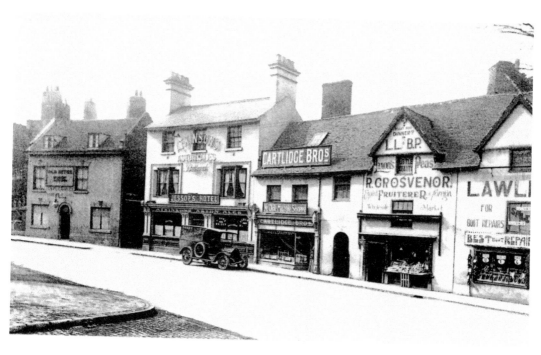

North Street

A very different North Street to what we see today. Jessop's Hotel can be seen with the Cartlidge brothers' 'Ye Olde Mangle Shoppe' next door, then a greengrocer and a cobblers. It is one of those scenes that has disappeared entirely; even the street no longer goes any further – it now leads to the back of the Civic Centre.

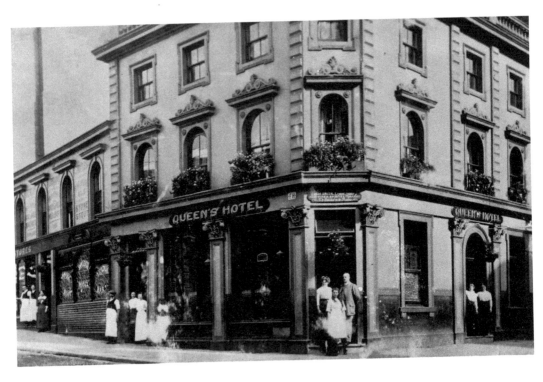

The Queen's Hotel, Cheapside

The Queen's Hotel at the corner of North Street and Cheapside, with staff posing outside. It is one of those few buildings in the city that has remained much the same over the past 100 years, though the name has changed more than once – it is now 'Popworld'.

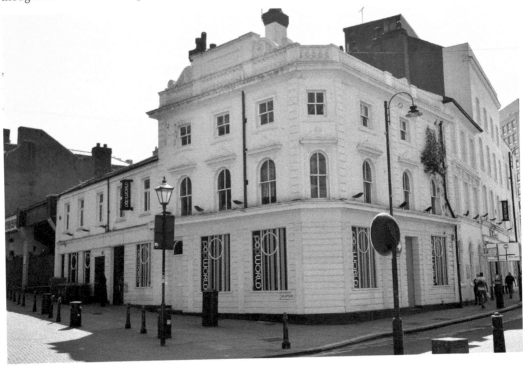

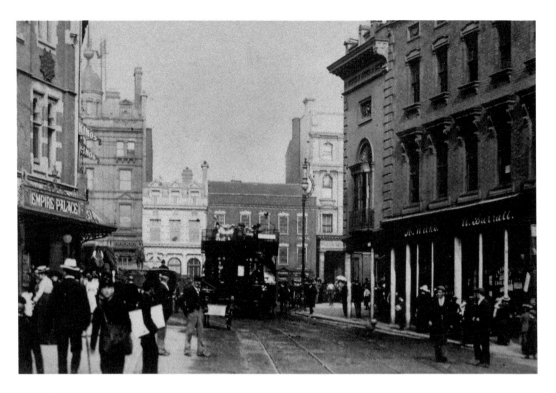

Queen Square

Another view of a busy Queen Square with a ubiquitous tram passing through. The Lloyds Bank building now dominates the southern end of the square, where once the well-loved Queen's Cinema and later a ballroom were housed.

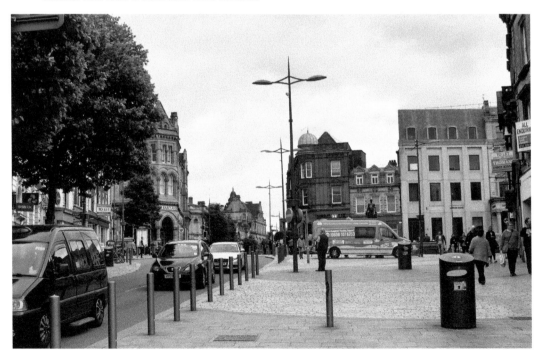

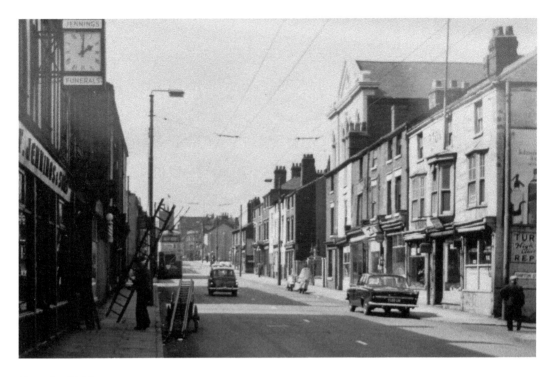

Horseley Fields

Here is a community that has now entirely disappeared: Horseley Fields, leading out to the Willenhall Road in the 1960s. Only Jennings the undertakers (seen on the left) still exists there today, but in a new building. For a while nobody lived in Horseley Fields as everything in this photograph was demolished, except for St Peter's Church in the distance; however, the new canalside flats has changed that.

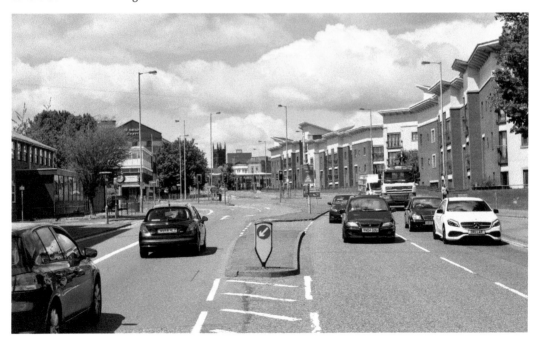

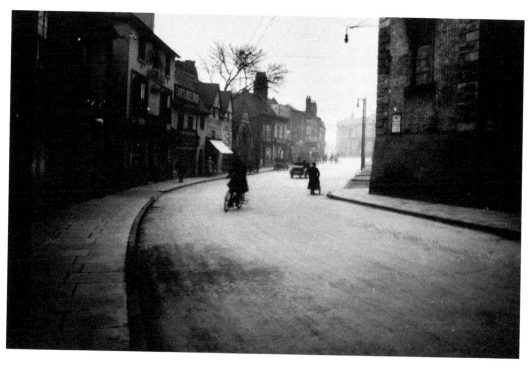

Bilston, Church Street

Bilston's Church Street on a grim winter's day with few shoppers. The Town Hall is on the right. The modern scene shows the area on a bright sunny day – the new trees in full leaf look so much better. The street has now been pedestrianised beyond the bend.

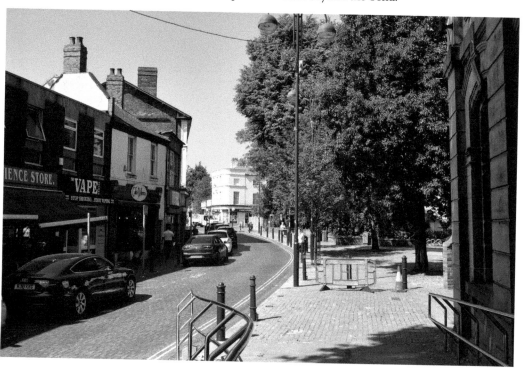

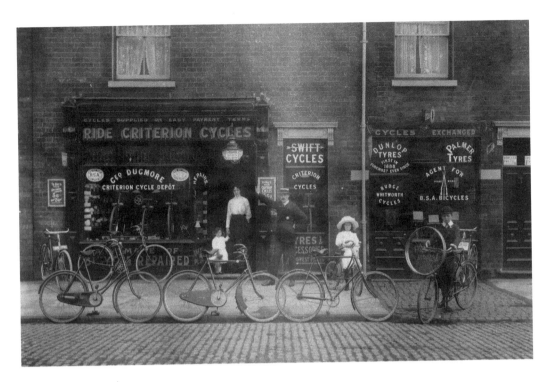

Dugmore's Cycle Shop, Bilston Road

Dugmore's Cycle Shop on Bilston Road in Monmore Green, with George Dugmore and his family outside. The cobbled street shows the tram tracks running by. NES Lighting took over the new Dugmore's building, which had been built on the same spot after it closed. Tram tracks run by the door once again.

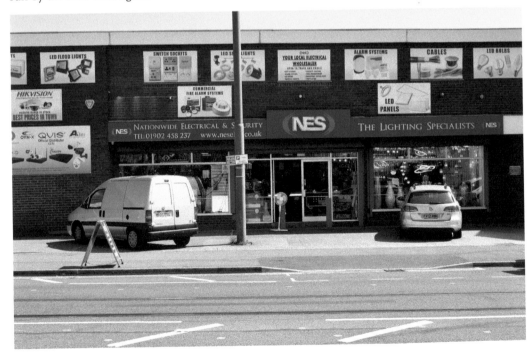

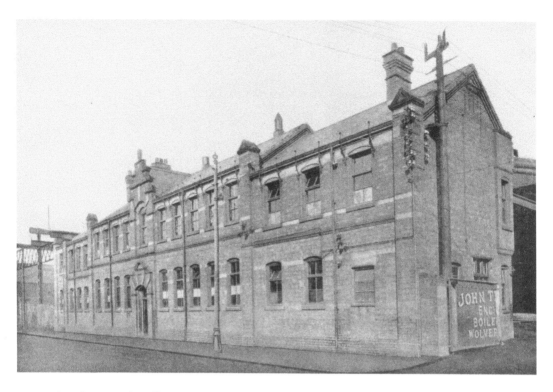

John Thompson's Offices, Ettingshall
The offices of John Thompson's Boiler Works in Ettinghsall. The company once dominated the triangle of land known as Catchem's Corner, but now other firms occupy those buildings. Only the central portion of John Thompson's offices still stand, occupied by Tile Choice.

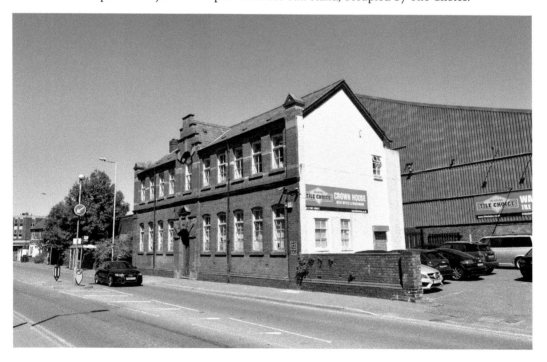

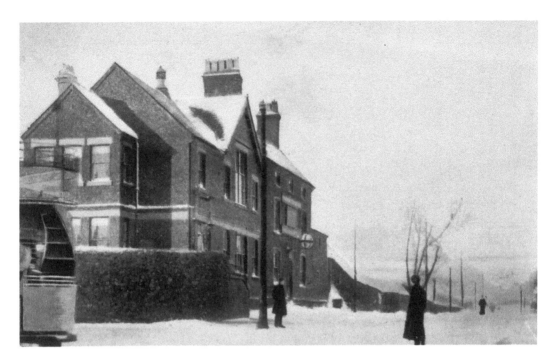

The Fighting Cocks

The Fighting Cocks public house looking up Goldthorn Hill on a snowy day. The tram to Dudley is still running despite the snow. The site of the Fighting Cocks is now an Aldi supermarket, though the area still retains the name of the pub.

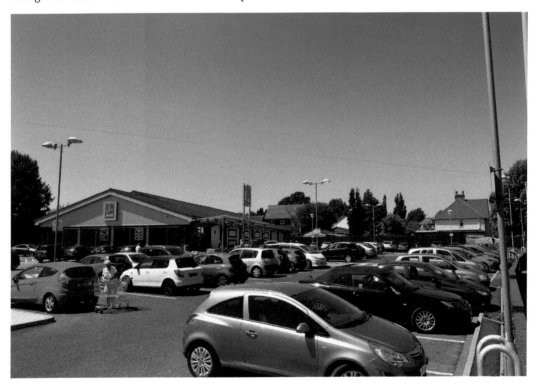

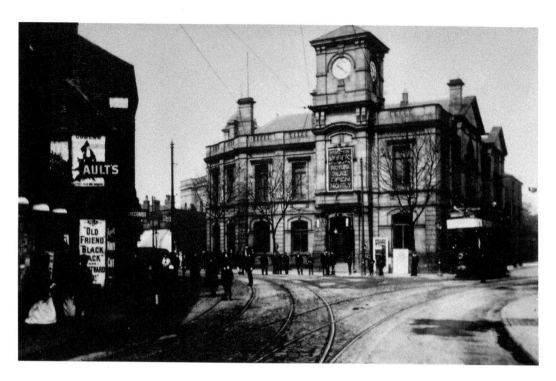

Bilston Town Hall

A tram for Wolverhampton is seen passing Bilston Town Hall, which is advertising 'Wood's Picture Palace open monthly'. There are trees in the old photograph, but, being winter, the leaves do not obscure the building as in the new photograph.

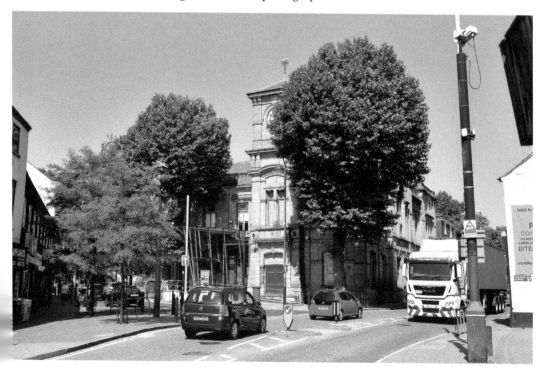

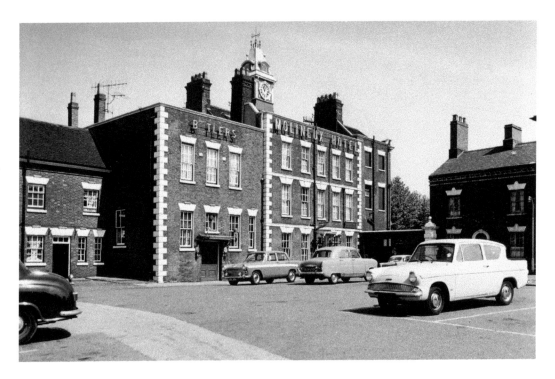

The Molineux Hotel

The Molineux Hotel in the 1960s. Ironmaster Benjamin Molineux gave his name not just to the house he bought from John Rotten, but to the hotel it became, the pleasure gardens that were opened in its grounds and, of course, the football stadium by which the name is known throughout the world. Cut off from the city centre by the ring road, the hotel suffered years of dereliction and then a fire, before being restored as the home of the City Archives.

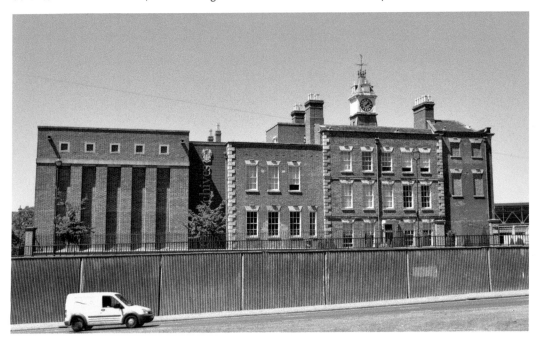

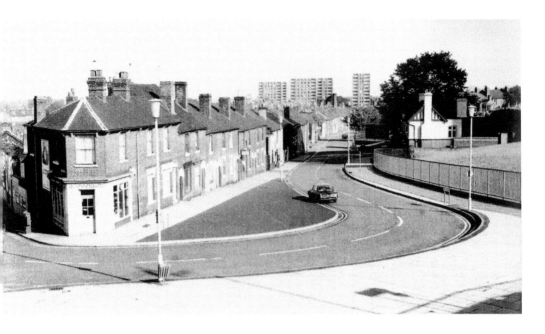

North Street

The view from the ring road down North Street just after it had been cut in two, apart from the pedestrian underpass beneath the road. It had been curved around to join Molineux Street, which ran alongside the stadium. The Fox public house is just about the only building surviving today (seen on the right-hand side of North Street), but the streets of terraced houses still stand that run down to Waterloo Road. The Steve Bull Stand, originally the John Ireland Stand, was built on top of Molineux Street and the whole stadium moved east over a period of twenty years. The Fox still survives, hidden beneath the trees, but has since been converted to a university office.

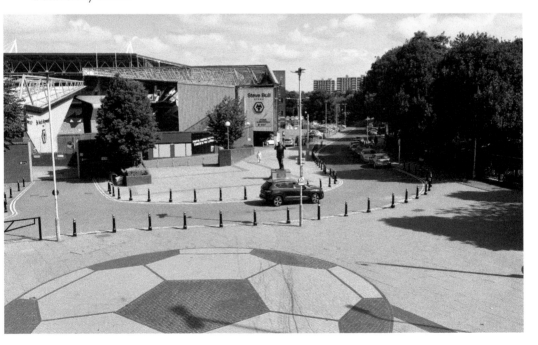

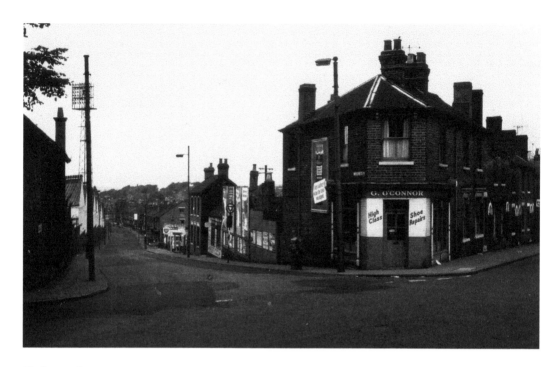

Molineux Street

Molineux Street running down to Waterloo Road, right behind the Molineux Street Stand of the Wolves' football ground. The football club bought up all the terraced houses in order to expand the ground. Nowadays, the statue of Sir Jack Hayward stands near the end where Molineux Street once started. He was a lifelong Wolves fan who bought and saved the club, helping to pay for much of the stadium's redevelopment.

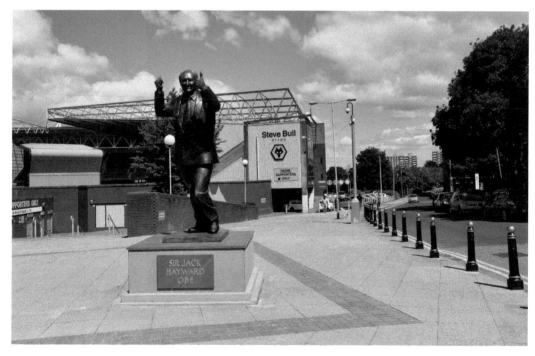

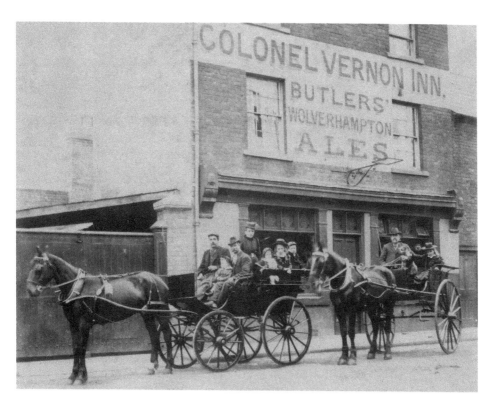

Colonel Vernon Inn, North Street

Another pub in North Street was the Colonel Vernon, and the landlord is shown here outside about to go on a trip to the countryside. The University of Wolverhampton's Business School is now located not far from the site of the Colonel Vernon, one of many university buildings along that side of North Street.

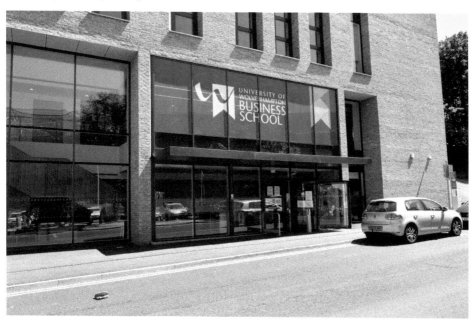

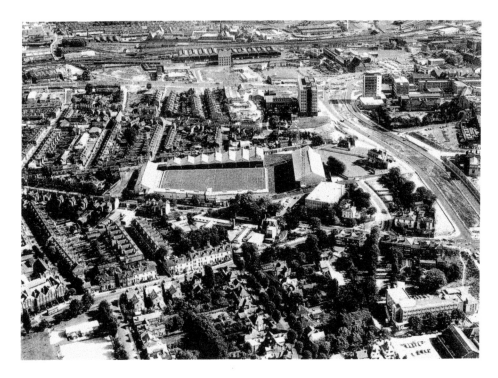

Molineux Stadium

An aerial view of Molineux Stadium in the 1960s showing the huge South Bank Stand to the right and the old Wolves indoor training facility alongside, which has since been demolished. Waterloo Road runs through the middle of the picture and all the streets of terraced houses above it have gone. An aerial view of the modern Molineux shows the largest stand has moved to the other end of the ground and there is an Asda now behind.

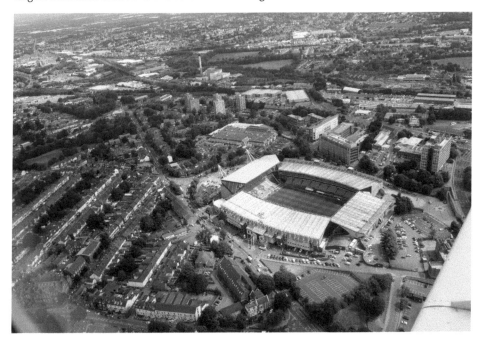

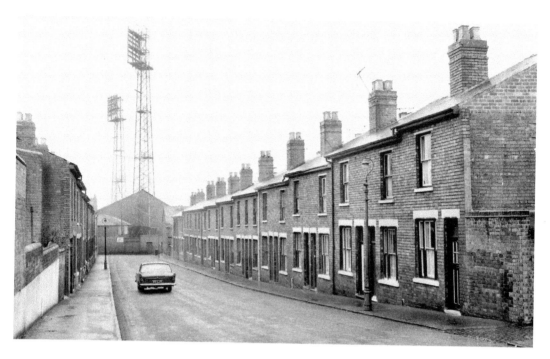

Dawson Street

One of the streets of terraced houses that ran between North Street and Molineux Street was Dawson Street, shown here on a non-match day with the end of the North Bank Stand and the floodlight pylons at the end. On a match day the street would be full of parked cars. All the terraced houses have now gone, replaced by car parks and an Asda supermarket. The line of Dawson Street is crossed by a new road, Sir Jack Hayward Way, with the North Bank Stand having been replaced by the huge Stan Cullis Stand.

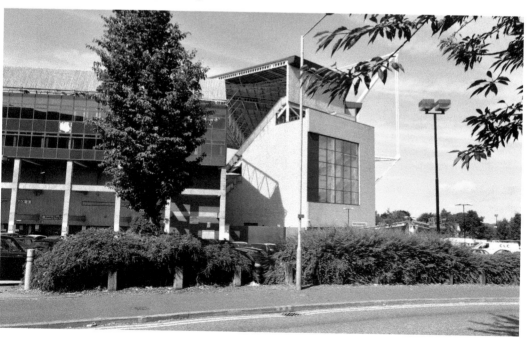

Five Ways Island

The Five Ways traffic island at the bottom of Stafford Street, with a bus turning from Stafford Road, then a single carriageway. The former Great Western Railway's Stafford Road Works dominates the top of the photograph. Not one of the buildings in this picture now survive. Nowadays trees line the new dual carriageway, rather than shops and houses.

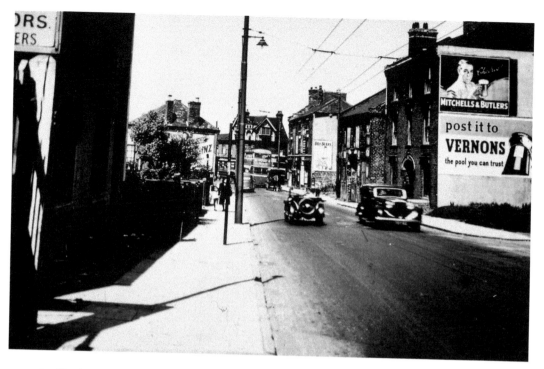

Stafford Street

Stafford Street running down to the Cannock Road junction just by the Elephant and Castle pub, in the centre of the picture. Every building in this scene is now gone – to make way for the new dual carriageway. The pub was the last to go, demolished just before it was to be listed. Stafford Street is now dominated by traffic and the chimney of the municipal incinerator in the background.

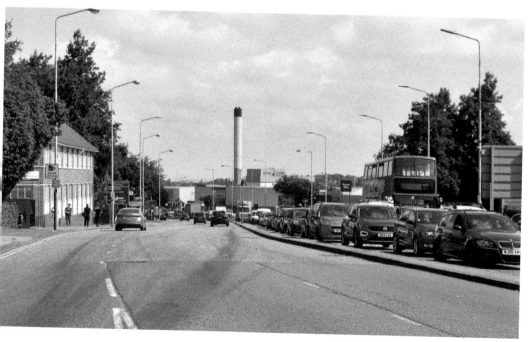

Stafford Street from Five Ways

Looking up Lower Stafford Street from Five Ways island, with the trolleybus wires overhead and terraced houses lining the road. With the whole of Stafford Road now a dual carriageway from the ring road out to the M54, or indeed the A5 at Gailey Island, all the buildings each side of the route are new. University student accommodation stands on the corner.

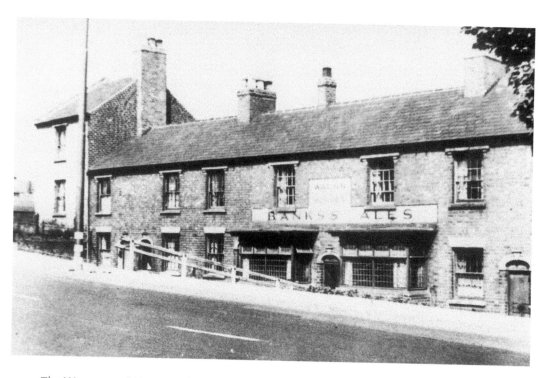

The Waggon and Horses Pub

The old Bank's Brewery Waggon and Horses pub on the Cannock Road, which lay opposite the Butler's Brewery Coach and Horses. This building was replaced by a new one, which has also now gone to be replaced by the Polish supermarket Casper.

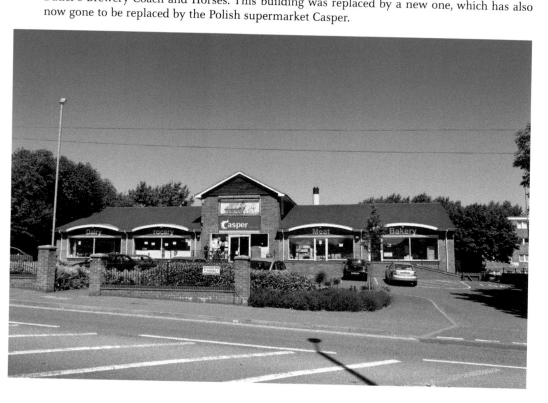

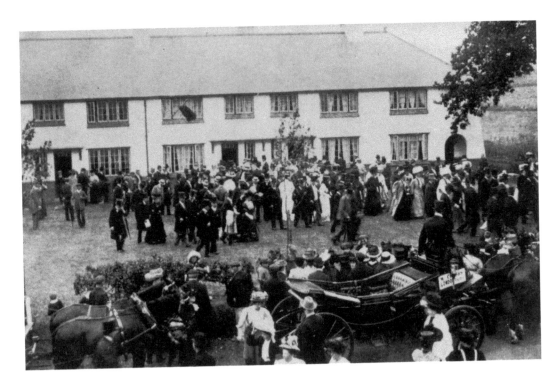

Victoria Road, Park Village

In 1908 the Garden Village movement came to Wolverhampton with the creation of Park Village, and on 9 July the first houses were opened. Later a model housing exhibition was created with local architects building examples of their designs. The terrace still stands, though there are now spaces for parked cars and there is no longer a hayfield beyond.

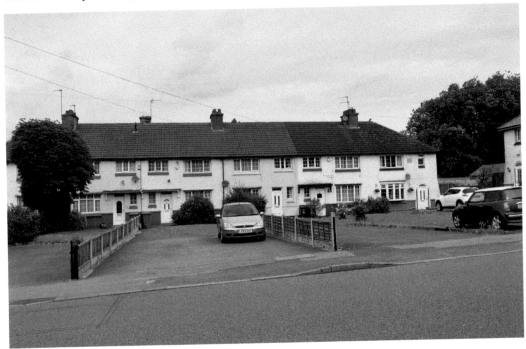

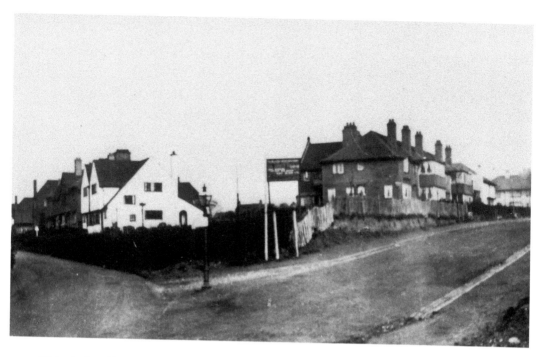

Victoria Road/Cannock Road Junction

The corner of Cannock Road to the left and Victoria Road, which lead into Park Village, a junction now graced with a mini roundabout. The gas lamp on the corner has been replaced by tall street lights and far more traffic.

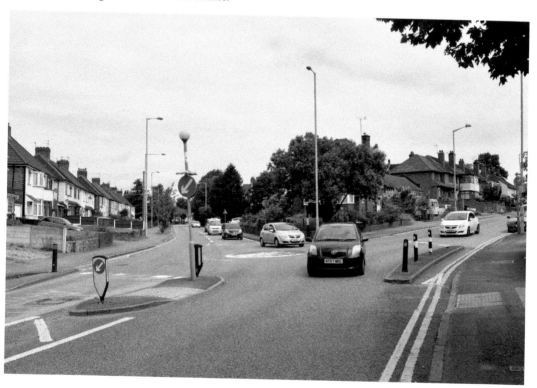

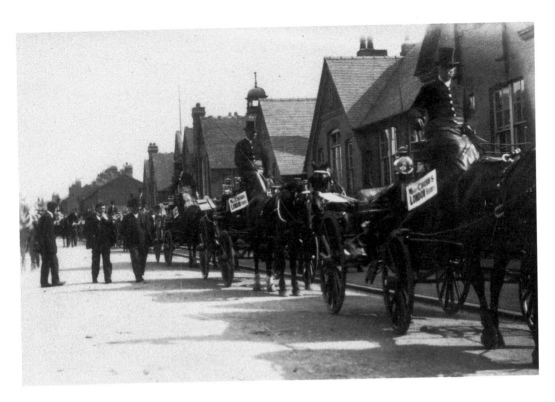

Woden Road School

The coaches to bring the VIPs to the Model Housing Exhibition were brought up from London and paid for by Chubbs, and here they are waiting outside Woden Road School, near to the shortly to be opened new Chubb lock and safe factory. Woden Road School is still much as it was, but Woden Road now contains SUVs and 4x4s.

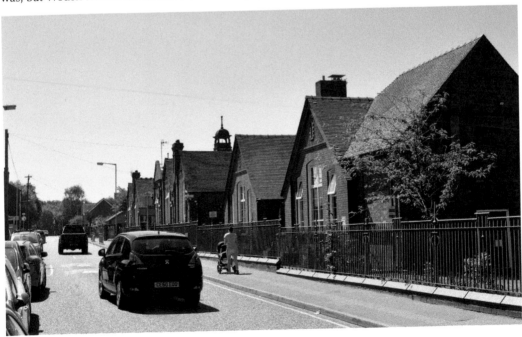

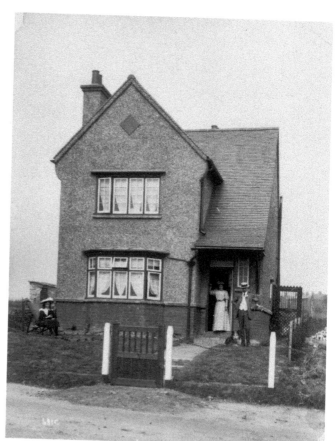

No. 224 Bushbury Road
One of the houses built for the Model Housing Exhibition was No. 224 Bushbury Road, which was bought by Mr Mattthews for £270 – seen in the garden with his wife and daughter. The house now has an extension, a garage, and the front garden is paved for parking.

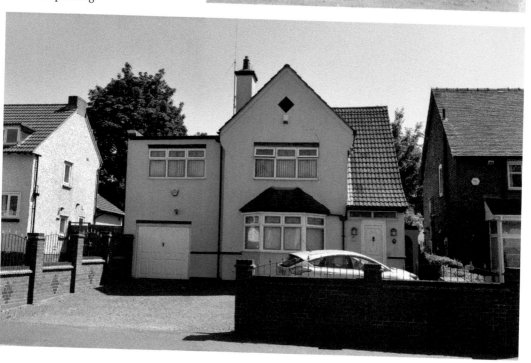

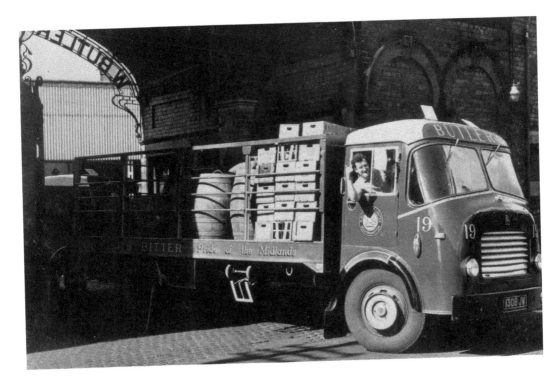

Springfield Brewery Entrance

A load of Butler's beers and stouts leaves the Springfield Brewery in the 1960s. Butler's were one of the two main brewers in Wolverhampton, though there were others. After its closure the site lay derelict for many years and then suffered a fire. It has now been taken on by the university and its restoration begun, thankfully including the fine entrance on Cambridge Street

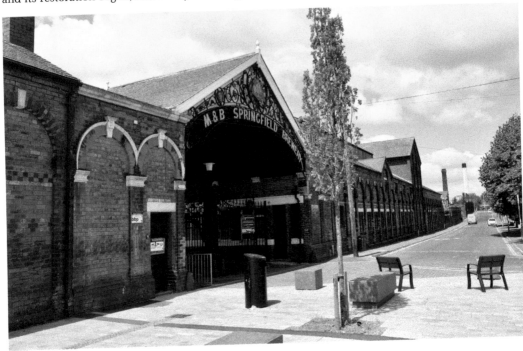

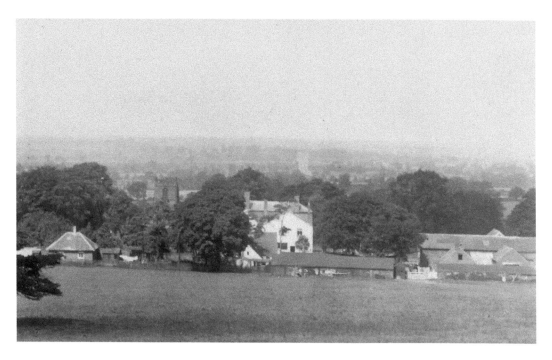

Bushbury Church from Bushbury Hill

A view from near the top of Bushbury Hill, which is the line of an ancient trackway, shows the St Mary's Church tower nestling in the trees, the vicarage and Bushbury Farm in an otherwise rural scene. The modern photograph shows little change in the foreground, but the background is dominated by the JLR factories on i54, and the flats in Fordhouses.

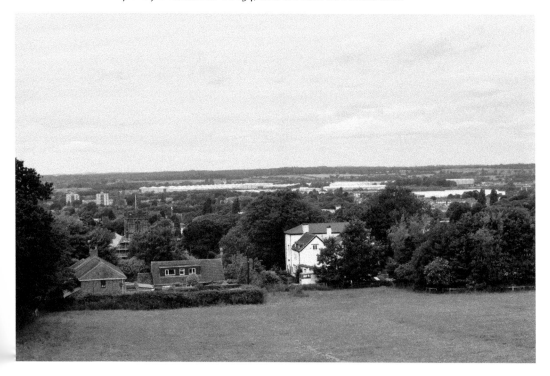

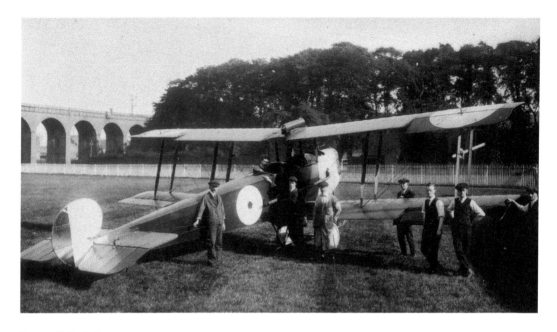

Dunstall Park Racecourse

In 1910, Dunstall Park Racecourse became Wolverhampton's airfield and continued as such, horse racing permitting, until 1919 when this photograph was taken. It shows an Avro 504 biplane, one of around 640 aircraft built by the Sunbeam Motor Car Co. during the First World War, experimentally fitted with a Sunbeam Dyak straight 6 engine instead of the usual rotary. A Dyak-powered Avro 504 became the first aircraft operated by Qantas. The Dunstall railway viaduct can be seen in the background. With the redevelopment of the racecourse into an oval shape, this corner was turned over to housing and car parking. The overhead gantries of the viaduct can just be seen in the modern photograph, along with the corner of the racecourse car park and the first of the houses beyond.

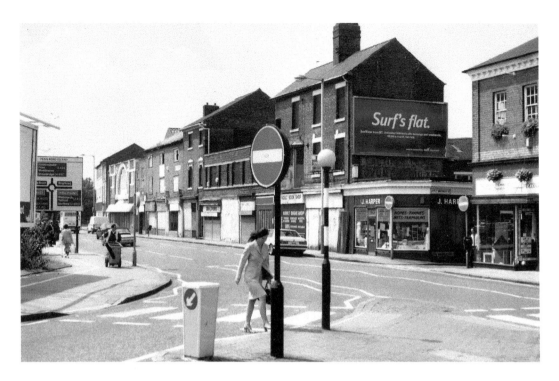

Worcester Street

The lower part of Worcester Street as recently as this century, showing a variety of shops, including J. Roper's famous ropes and tackle shop and the Scala dance hall, which had started life as a cinema further down the street. The Scala and most of the shops have now been cleared away and The Way youth centre built in their stead.

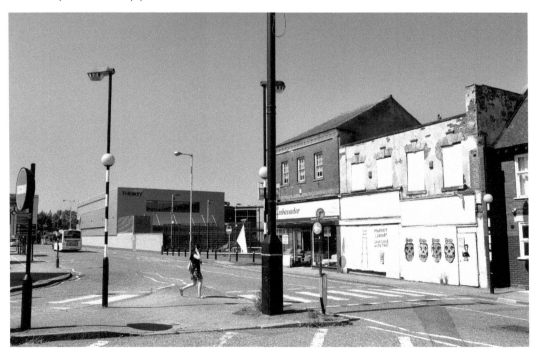

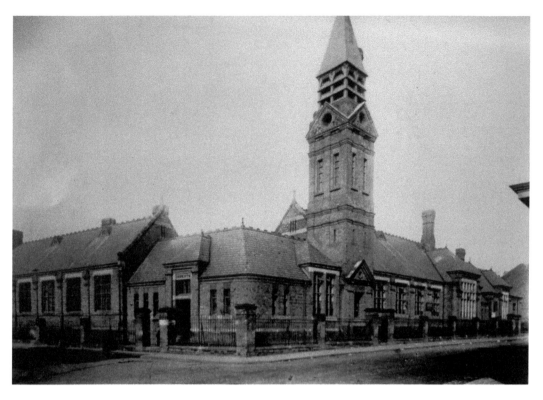

Brickkiln Street School, Graisley

Brickkiln Street School, Great Brickkiln Street, Graisley, which opened in March 1878, is seen here with its imposing tower. The tower has since gone and the building is now Nishkam Primary School.

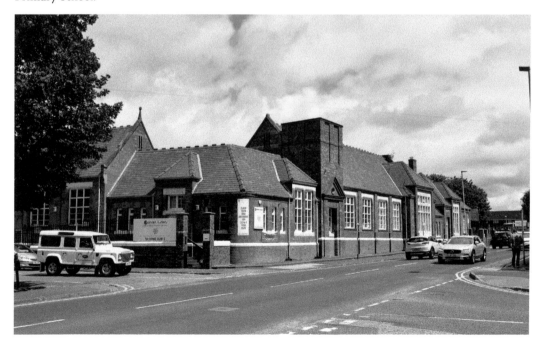

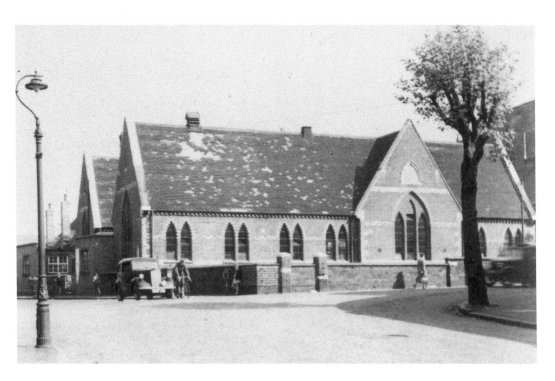

St Luke's School, Blakenhall
St Luke's Primary School in Upper Villiers Street, Blakenhall, famously the home of Wolverhampton Wanderers, who were founded here. St Luke's Church stands just behind. Nowadays the old school building has been demolished and replaced by a new building on the other side of the beautiful ornate brick church, which is itself being redeveloped as an antiques centre.

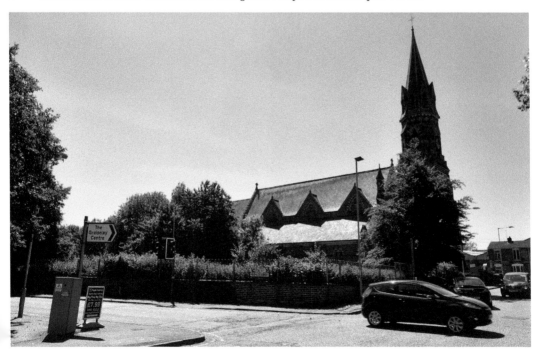

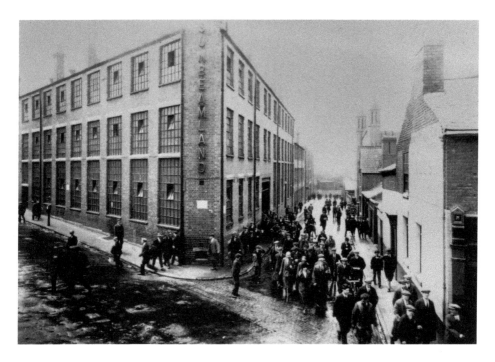

Sunbeamland

Workers pouring out of Sunbeamland into Paul Street, Blakenhall. This was the factory of John Marston Ltd, where Sunbeam bicycles and later motorcycles were made until 1937, when production was moved to London. Marston's continued to operate as radiator/heat exchanger manufacturers and are now part of the vast UTC complex. After use by other companies Sunbeamland became derelict, but is now being redeveloped into apartments under the heading 'Living @ Sunbeamland'.

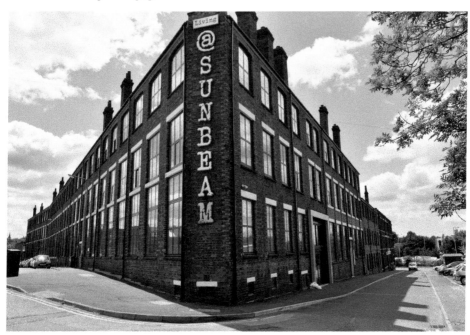

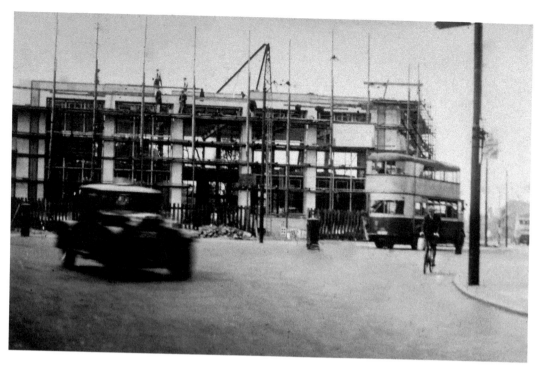

Penn Road/Lea Road Junction

The Midland Counties Dairy Building being constructed on the corner of Lea Road (where the bus has entered) and Penn Road. This white-tiled building was a marked feature of the townscape for many years, but the site is now occupied by a McDonald's.

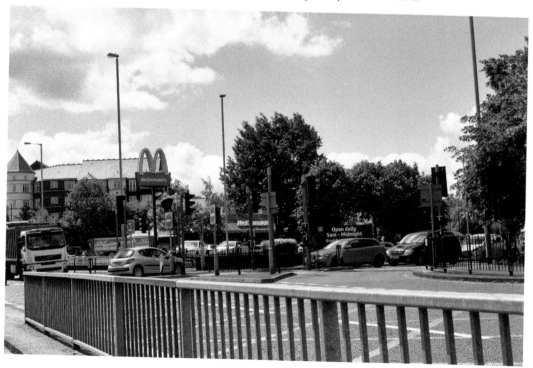

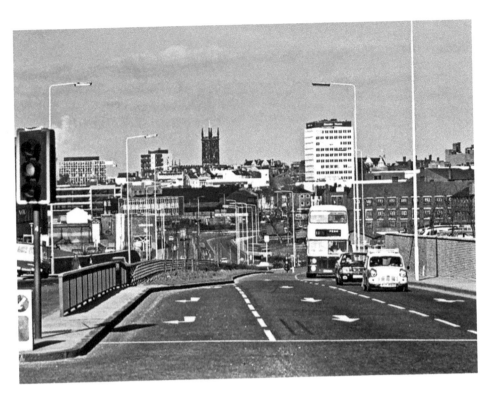

Town Centre from the Penn Road

A 1970s view of the town centre along the Penn Road, from the junction with Marston Road. St Peter's Church, the College of Art and Design, the adjacent Polytechnic Block and Mander House dominate the skyline. The view from the same spot today illustrates how verdant the city has become.

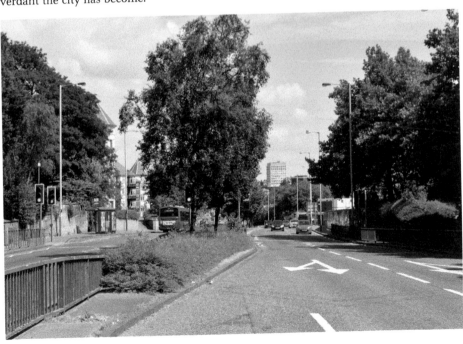

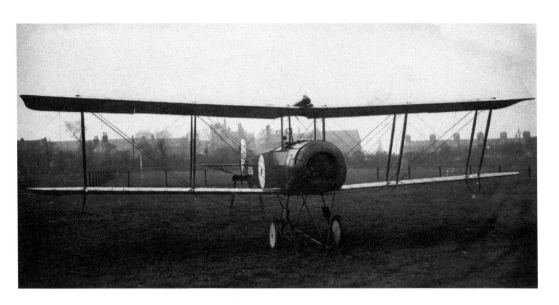

The Rear of the Sunbeam Motor Car Co.

One of nearly 600 Avro 504 trainers built by the Sunbeam Motor Car Co. of Upper Villiers Street during the First World War. It has been erected in a field behind the factory with the buildings of the Royal Orphanage (now the Royal School) in the background. The same field today has had industrial units built upon it, though the Royal School is just visible through the trees. Most of the Sunbeam factory is still there, but split into small units tenanted by many companies.

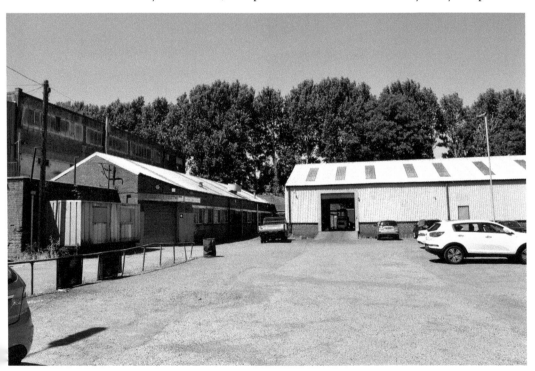

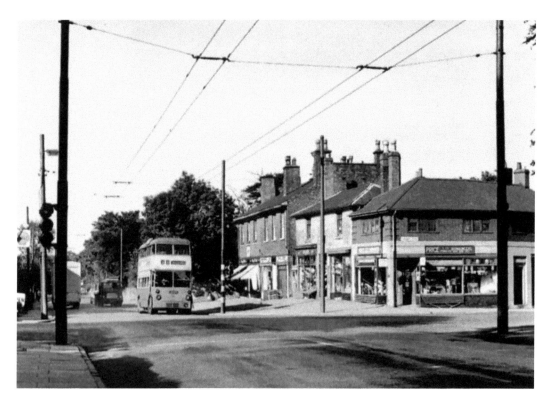

The Penn Road at Coalway Road Junction

A trolleybus heads for the town centre along the Penn Road, with Coalway Road to the right. A bus at the same spot today passes the same row of shops, though with different tenants.

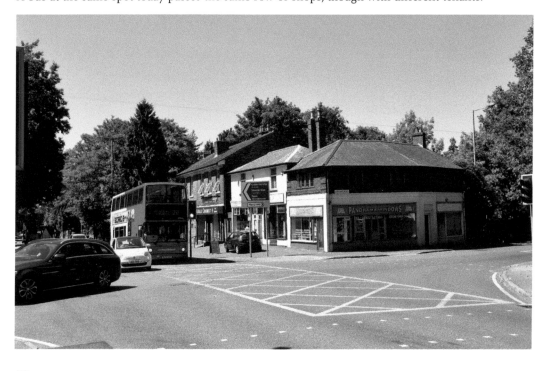

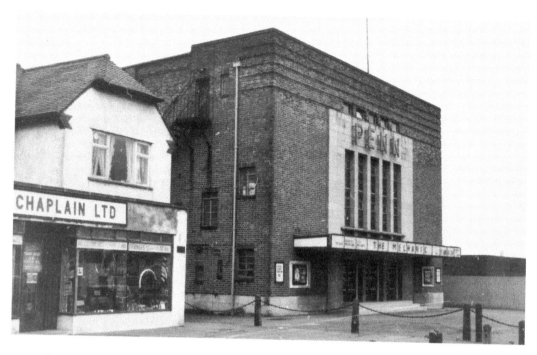

The Penn Cinema, Warstones Road

The Penn Cinema on Warstones Road, one of a chain of forty-six cinemas owned by B. T. Davies. It is showing Michael Winner's film *The Mechanic*, starring Charles Bronson, which came out in 1972. The cinema closed in 1973 and was later demolished and replaced by a Gateway Supermarket (now a Co-op). The electrical shop next door is now a Chinese takeaway.

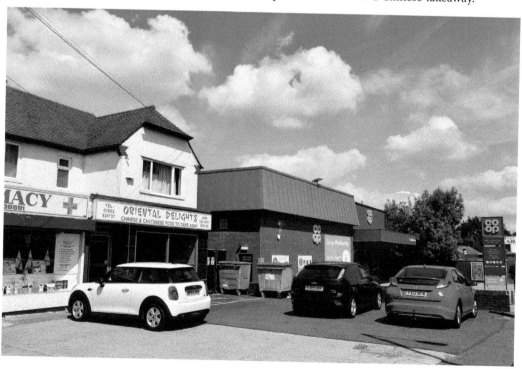

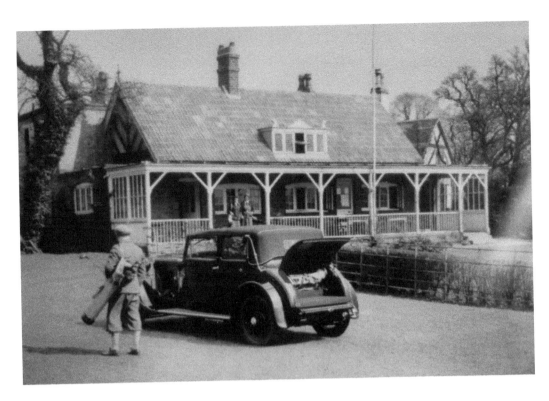

Penn Golf Club

A golfer set for a round at Penn Golf Club in the 1930s, having taken his clubs from his Sunbeam car. The club had received the right to use Penn Common as a golf course in 1892, where a racecourse had once been. This clubhouse was built next to the Barley Mow pub. Nowadays a far larger new clubhouse stands on the spot.

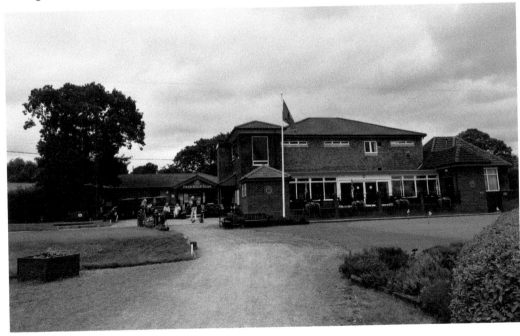

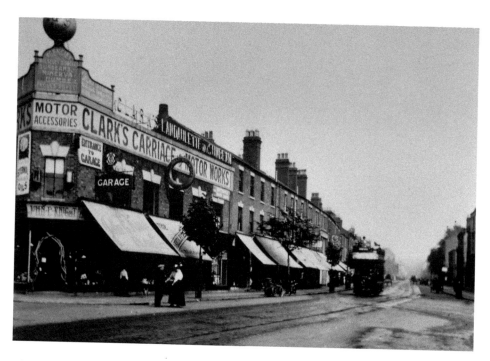

Chapel Ash

Charles Clark's car dealership in Chapel Ash before the First World War, with a tram just having passed on the way to town from Tettenhall. The company traded here until the 1970s when they moved to a larger building just round the corner. All these buildings remain, though with different tenants. Where the tram stood, an electric hybrid bus stands in the modern picture (also on its way from Tettenhall) and there are many cars, even outside of rush hour (the time on the clock being incorrect).

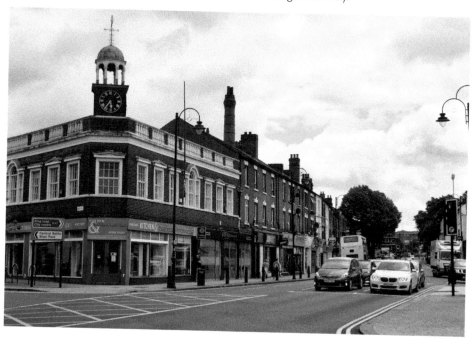

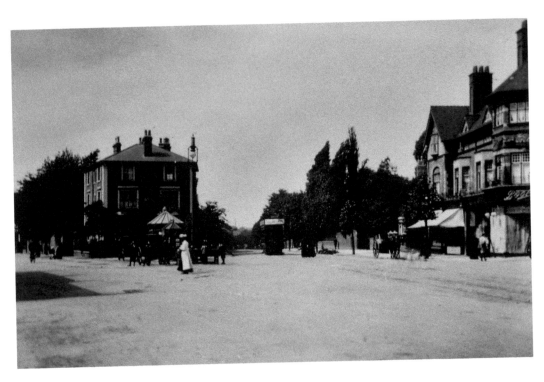

Compton Road/Tettenhall Road Junction

This view looks the opposite way from the previous picture, with Tettenhall Road now to the right and Compton Road to the left. The modern photograph shows the same buildings, all still in use, but rather more road signs and street furniture.

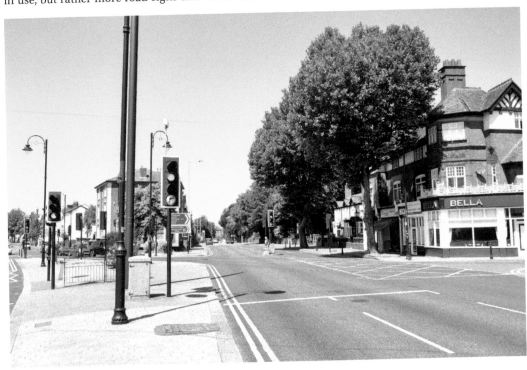

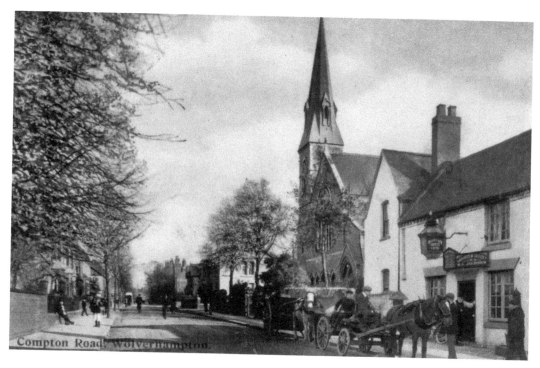

Compton Road

The Holy Trinity Church and the Quarterhouse Inn on the Compton Road in 1910. The wagoners look more likely to have stopped for a 'livener' than a delivery. Both the 1862 church and the inn have now been demolished and replaced with a Sainsbury's supermarket.

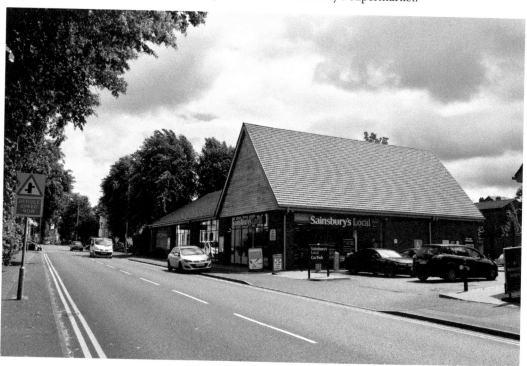

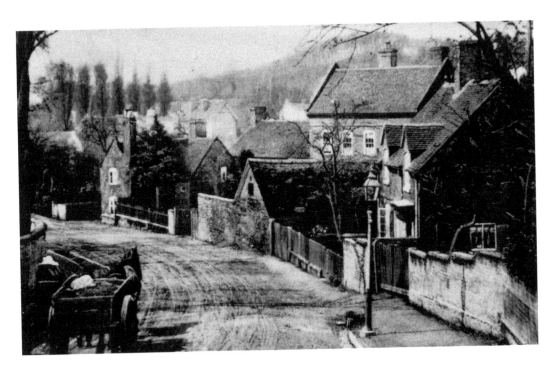

Lower Compton Road

A little further along Compton Road, where it drops down by Compton Farm to the Smestow Brook. The village of Compton lay well outside of Wolverhampton at the time and was part of Tettenhall parish. The view today shows most of the buildings have survived, though the farm no longer operates and most of its fields are covered with houses.

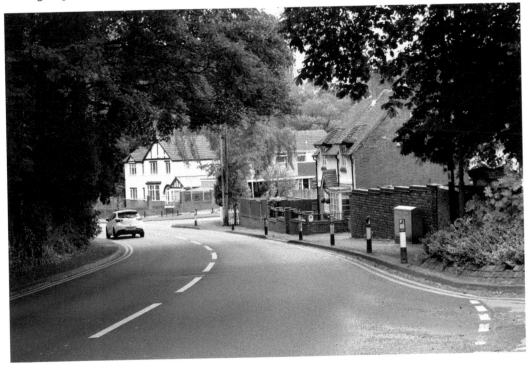

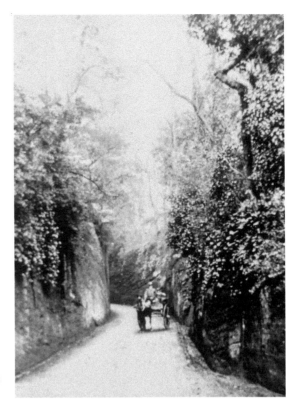

Wightwick Bank

A pony and trap descend the steep cutting of Wightwick Bank *c.* 1900. This was one of three steep roads up Tettenhall Ridge from the lowest point of the area, the valley of Smestow Brook – the others being Compton Holloway and the Rock. Wightwick Manor lay to the left-hand side of this hill. The modern picture shows the road to have been widened, and it is now a Porsche which ascends the hill.

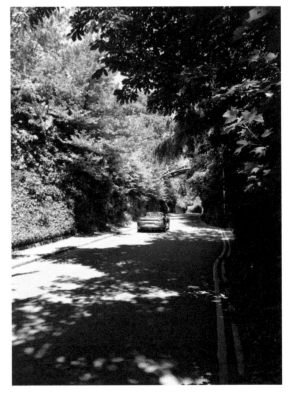

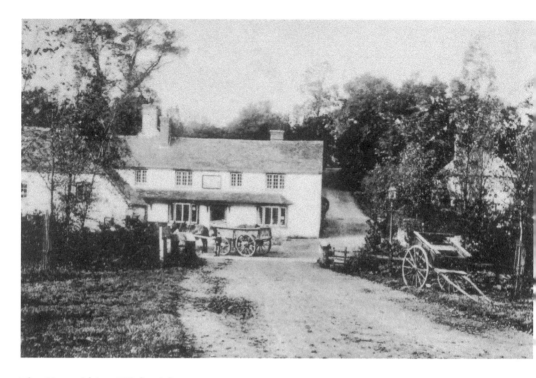

The Mermaid Inn, Wightwick

The Mermaid Inn at the bottom of Wightwick Bank, on the Bridgnorth Road. There was a smithy to the left of the inn, on what was a sleepy rural crossroads. The Mermaid is still there, though the smithy was demolished to enlarge the car park, and the much busier junction has required traffic lights for some time now.

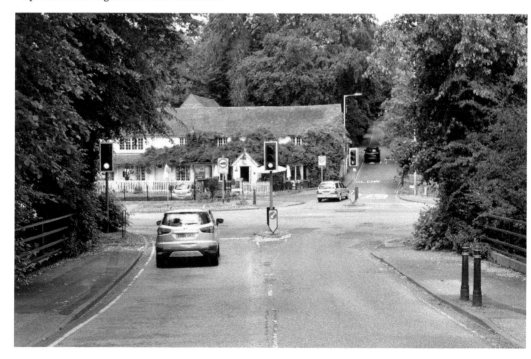

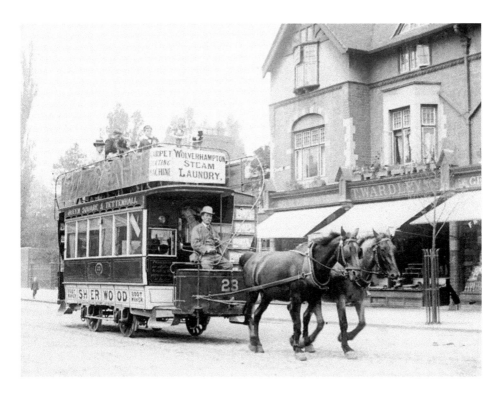

Public Transport in Chapel Ash

A horse-drawn tram plies the route between Tettenhall and Queen Square, just passing the shops at the start of Chapel Ash. The horse-drawn trams, which had started on this route in 1878, were replaced by electric trams in 1902. Nowadays an electric hybrid bus runs on the No. 1 route from Tettenhall to Wolverhampton, then onwards all the way to Dudley. The shops are mostly the same, but T. Wardley's shop has been replaced by a sushi restaurant.

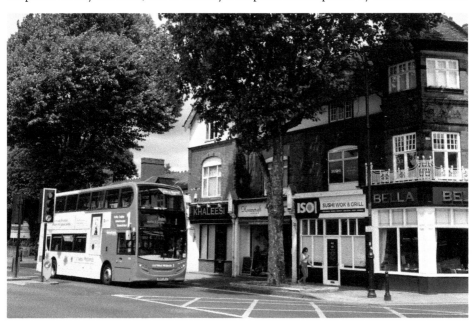

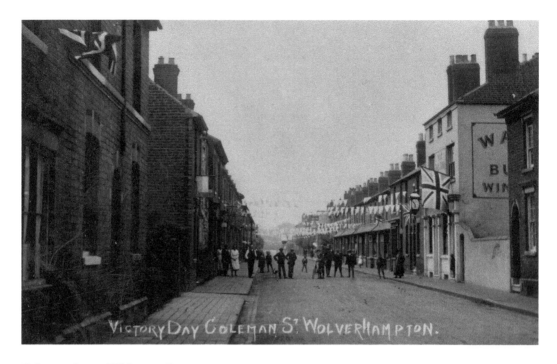

Coleman Street, Whitmore Reans

Coleman Street in Whitmore Reans seen here decorated for Victory Day at the end of the First World War. It is typical of the streets of terraced houses in the area, which have seen piecemeal redevelopment. The Three Crowns pub on the right was replaced by a larger one on the same site, using the old pub as the basis. This, too, was lost in the 1980s. Some of the terraced houses have been replaced, but some remain. In other parts of Whitmore Reans whole streets have been replaced.

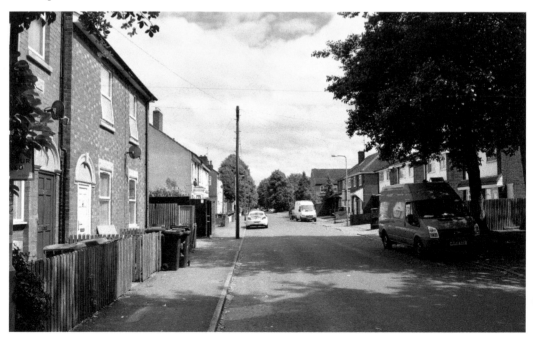

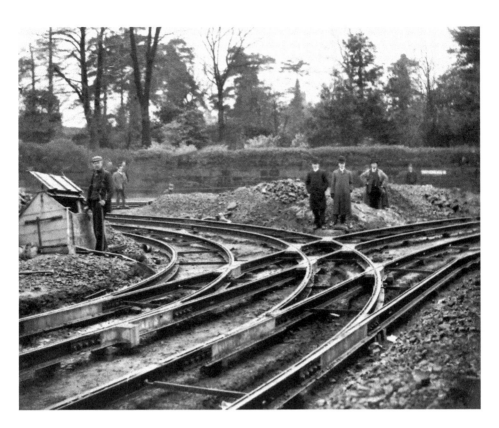

Newhampton Road/Tettenhall Road Junction

The laying of the tram tracks in 1902 at the bottom of Newhampton Road, where it joins the Tettenhall Road. Those to town curve to the left. The tracks were taken up in the 1920s when trolleybuses replaced trams.

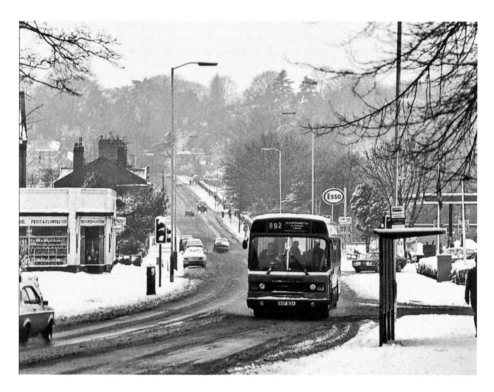

Tettenhall Road, Newbridge

A snowy day at Newbridge in the 1980s, with the 892 service from Telford on its way into town having come down the Rock in the distance. Even in the short time since this photograph was taken the shops on the left have been replaced, and the Esso garage over the road has gone altogether.

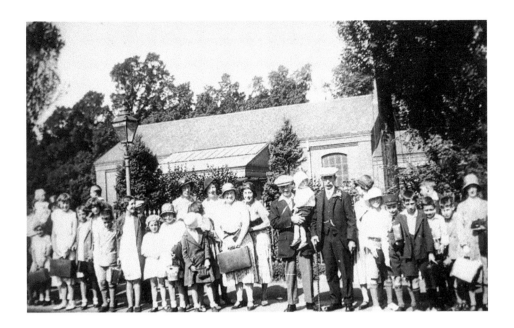

Tettenhall Station

People waiting for a train at Tettenhall station for a day trip to Rhyl in 1932. Scheduled passenger services on this line ended in that year, only seven years after the line opened; however, specials were still run along it right up until its final year in 1965. In the background is the GWR goods depot. The platform building nowadays is Cupcake Lane Café and the track is Smestow Valley cycle and foot path. In the background, the former goods depot has become Tettenhall Transport Heritage Centre, which is open every weekend.

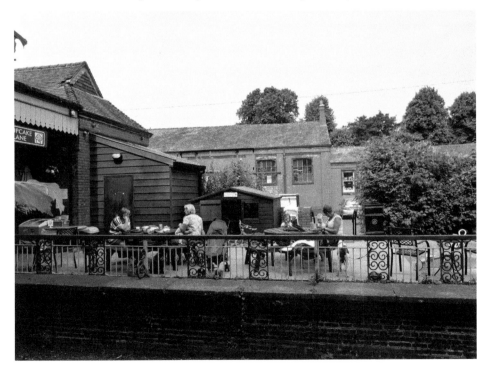

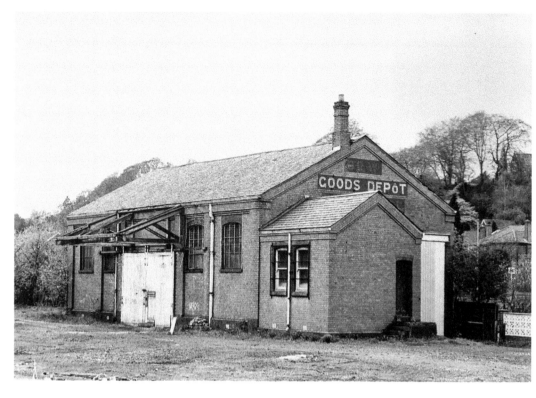

GWR Goods Depot, Tettenhall

For many years Tettenhall station remained derelict. The goods depot was used for storage for a while, but the canopy over the side door to the lorry loading bay became dangerous and was demolished. A huge amount of EU money was received to build the car park and restore the other station buildings, but not the goods depot. In 2014 a volunteer-run charity opened the Tettenhall Transport Heritage Centre and began the task of restoring the building and the exhibits inside, which attempts to preserve Wolverhampton's transport heritage – whether rail, road, air or canal.

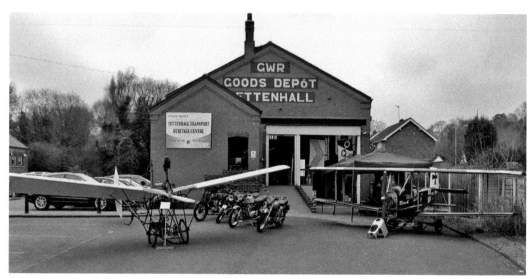

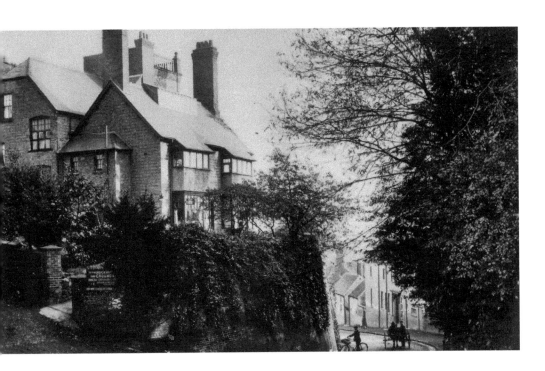

The Rock Hotel, Tettenhall

Near the top of the old road up Tettenhall Ridge lies the Rock Hotel, which has fine views over Wolverhampton town centre on the other side of the valley. Before the new road was built, wagons and coaches were forced to climb this steep hill, and for a while there was a windlass just opposite the entrance to the hotel to help them up. The hotel has now been renamed Goodwins.

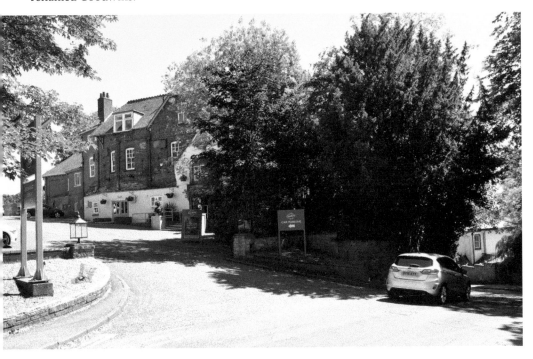

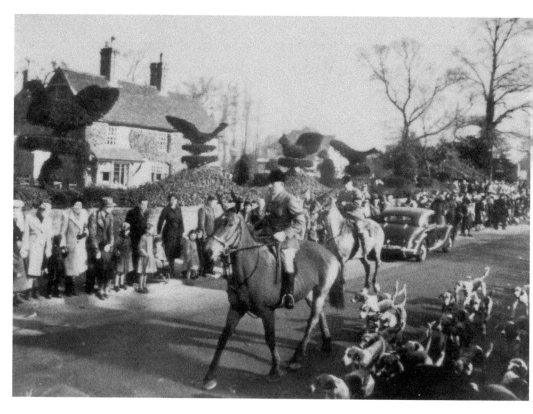

The Crown at the Wergs

The Albrighton Hunt passes the wonderful topiary of the Crown public house at the Wergs, on their way out of town in the 1950s. The Crown is still open today, if much enlarged. The section of road outside is now a dual carriageway and it's impossible to imagine a fox hunt ever passing this way again.

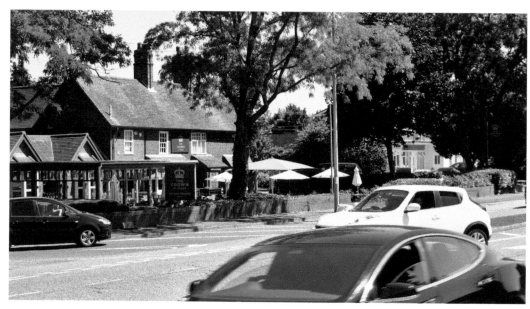

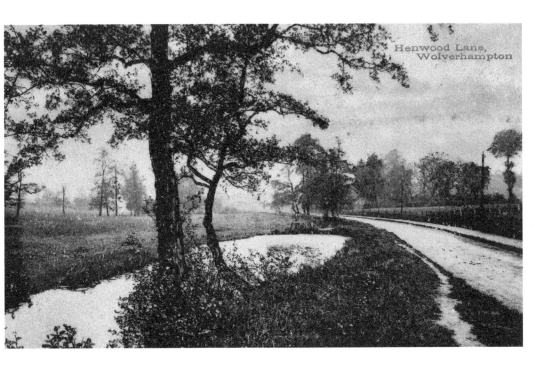

Henwood Lane

The pond in Henwood Lane seen here around the turn of the nineteenth century, when this was well and truly out in the country. It is now fully built up and the bungalows on the left were built as prefabs (prefabricated houses) after the Second World War. They have since been updated and reclad in brick.

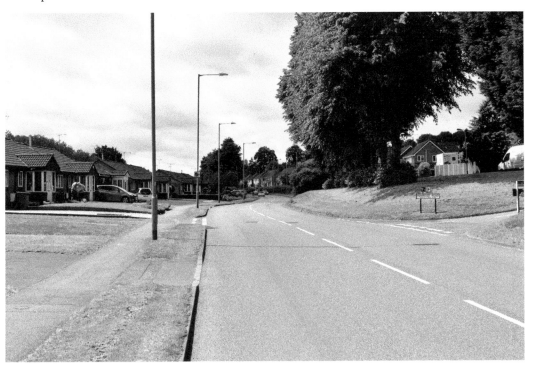

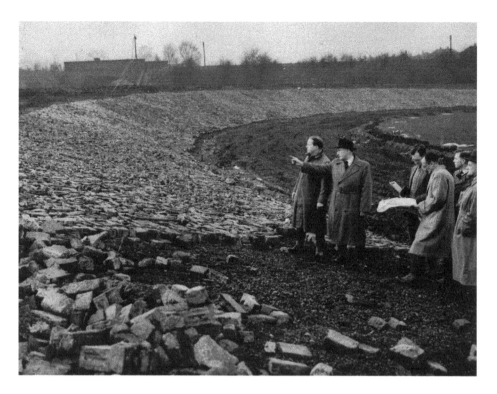

Aldersley Stadium

Aldersley Stadium being built in 1956 as a home for fifteen sports, including cycling, with a cycle track around the outside. It was built on Autherley Farm, which had been bought by the council. The stadium today is the home of Wolverhampton & Bilston Athletic Club and Wolverhampton Wheelers Cycling Club, among others.

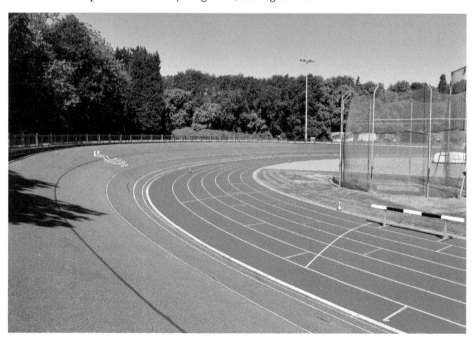

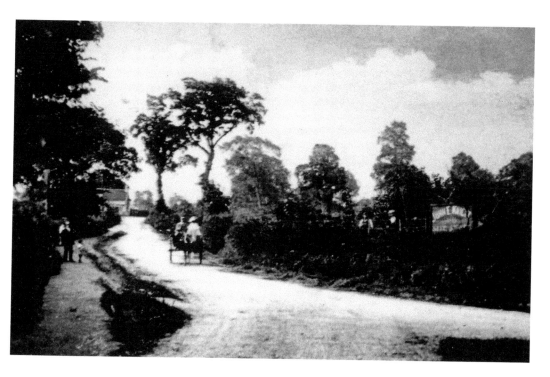

Codsall Road from Claregate Island

The Codsall to Wolverhampton road at Claregate *c.* 1900, with a pony and trap just having been driven by the Olde Fieldhouse in the background. Two workers in Knight's Nurseries peer over the hedge. A traffic island now occupies the junction, which also leads to Knights Avenue, Blackburn Avenue and Pendeford Lane.

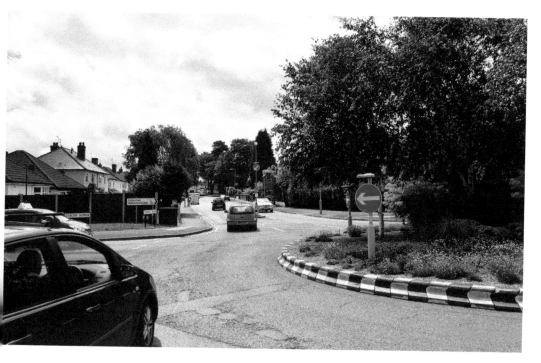

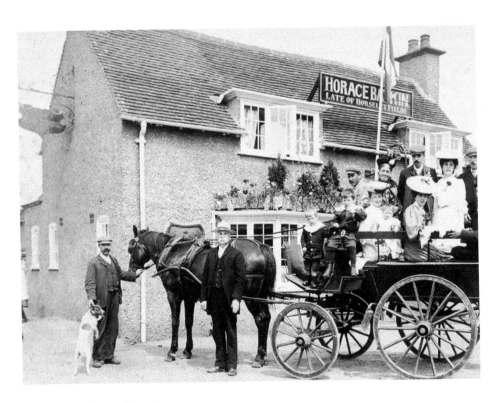

Ye Olde Fieldhouse/The Claregate

Ye Olde Fieldhouse at Claregate, *c.* 1900, when the landlord was Horace Batkin. Batkin can be seen here with a group about to go on a trip. This building was later replaced by a much larger one named The Fieldhouse, later renamed The Claregate. It had a recent makeover when it was made a 'Generous George' pub; a section of its car park is now a Tesco Extra.

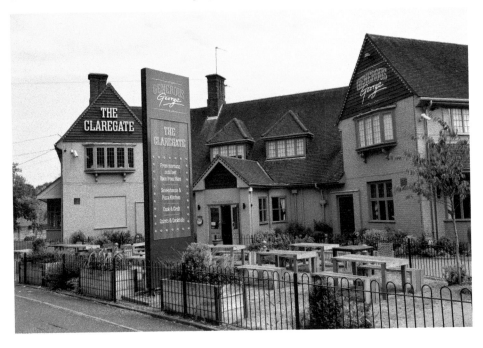

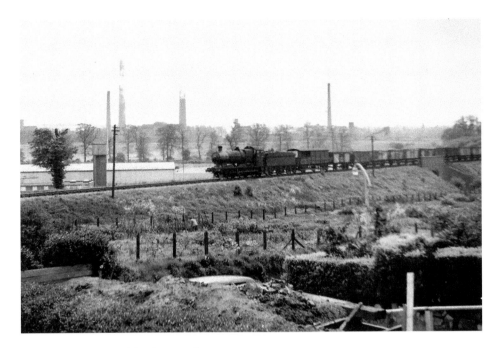

The Railway from Aldersley Road

A goods train passes along the line from Tettenhall towards Oxley, with the roof of Aldersley Stadium and the Three Sisters chimneys of Courtaulds factory behind. The photo was taken from one of the houses on Aldersley Road, a car roof just being visible in the foreground. There were no houses on the other side. Today the railway has closed and a new entrance to Aldersley Stadium built across it. The building in the background is the small arms shooting range next to the stadium and the chimney is that of the incinerator, visible behind the grandstand of Dunstall Park racecourse.

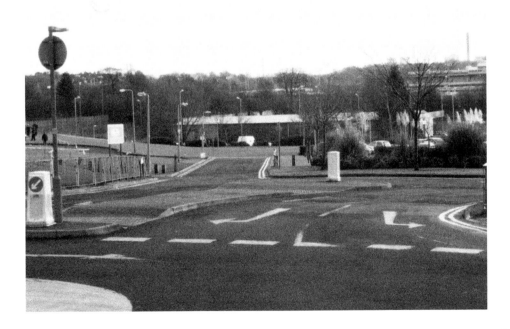

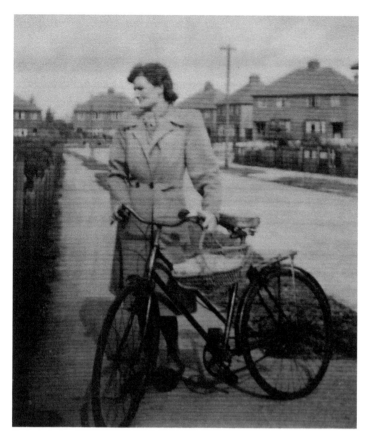

Blakeley Avenue, Claregate

Mrs Jeggering, a Dutch lady, standing outside her house in Blakeley Avenue, Claregate, during the war. In effect a refugee, her husband was serving with the Princess Irene Brigade of the Dutch Army based locally at Wrottesley Park. Blakeley Avenue was part of the Blakeley Green estate's development. It was started just before the war and not finished until afterwards. On the same spot Sandra Squires of Tettenhall holds a modern mountain bike in what has become a mature suburb.

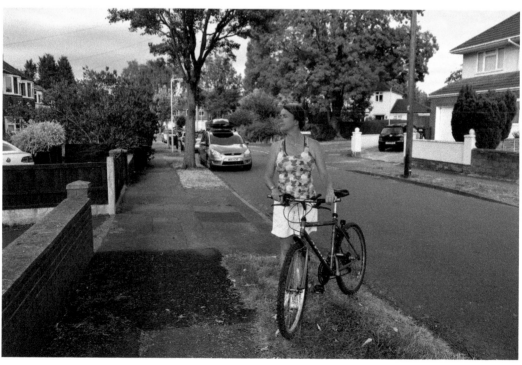

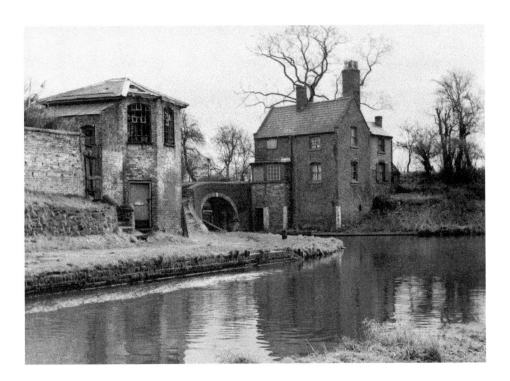

Aldersley Canal Junction

The junction of the Staffs & Worcester Canal and the Birmingham Canal Navigations, showing the first of twenty-two locks going up to Wolverhampton town centre. The building on the right is the BCN offices and toll hous; that on the left is the Staffs & Worcs toll house. To the left of this there was also a terrace of four canal workers' cottages. All those buildings have now gone and the canal junction, formerly one of the most important and busiest in the country, is very peaceful.

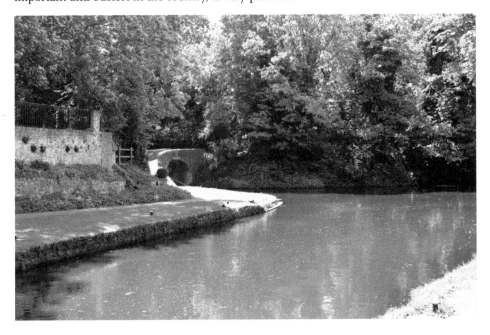

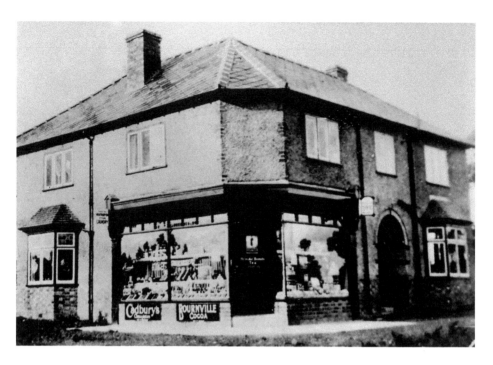

Claregate Post Office

Claregate Post Office at the corner of Blackburn Avenue and the Codsall Road, built just before the Second World War when developers were building new houses in the fields all around the area. The post office has now become Hail to the Ale micropub, with a hairdresser occupying the house next door. Happily there is a nod to its former use as a postman's bicycle stands outside, planted with flowers in the front basket.

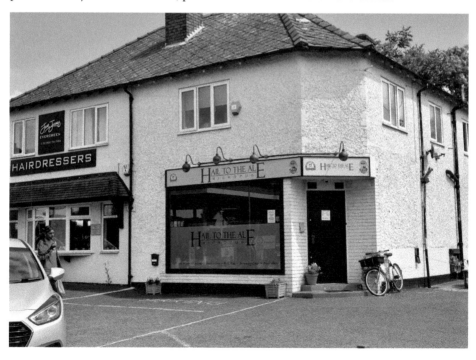

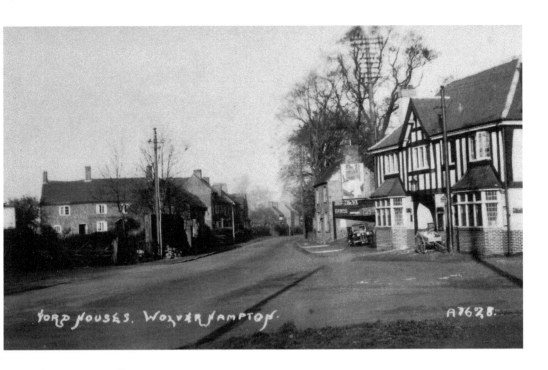

FORD HOUSES, WOLVERHAMPTON. A7628.

The Vine at Fordhouses

The Vine public house on the Stafford Road, with houses and the Gate pub further along the road towards Stafford. Everything in the 1930s photograph has now gone. Flats occupy the site of the pub and factories line the other side of the road, which has long since been made a dual carriageway. The junction is still known as Vine Island.

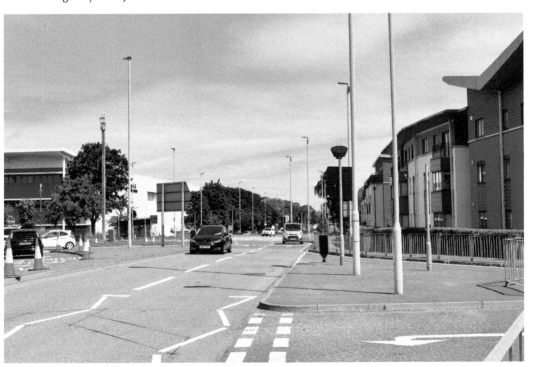

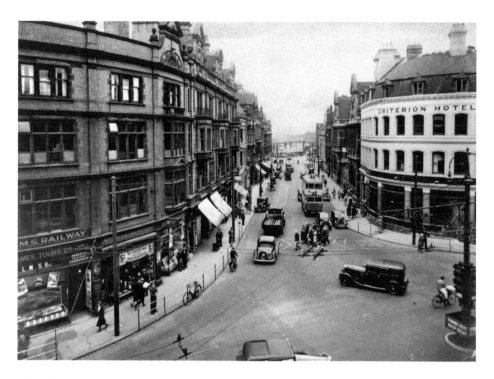

Prince's Square

Prince's Square has changed little over the last eighty years, except for the uses put to the buildings – particularly the Criterion Hotel, which is now a university office. In the distance Victoria Square can be seen, which has changed much more. Prince's Square was the site of the first automated traffic lights in Europe, which can be seen in the centre. Traffic lights still operate here, though changing traffic patterns have meant the junction is far less busy.

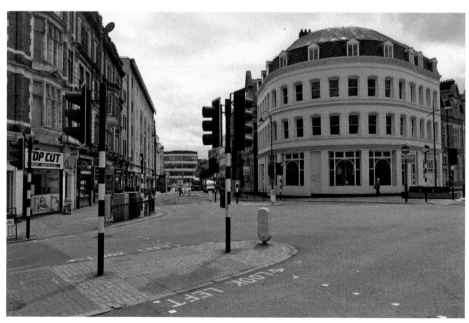

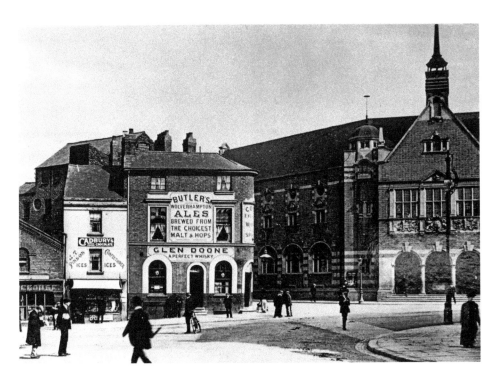

The Central Library

Wolverhampton's Central Library was built in 1900 with Queen Victoria's Silver Jubilee Fund. The Theatre Royal, on the corner of Garrick Street and Cleveland Road, was knocked down to provide the site. There is 118 years between these images and things on this junction have changed. Firstly, the buildings on the other side of Garrick Street were swept away to create the Wulfrun Centre, and secondly pedestrians no longer stroll haphazardly across the road.

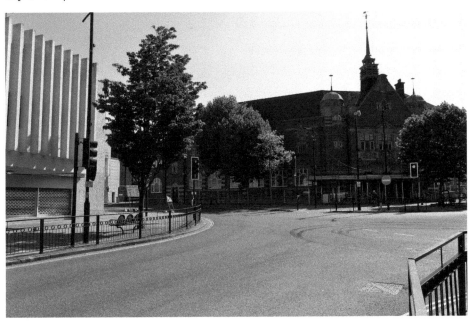

Acknowledgements

Many of the old photographs included here have been collected over a period of thirty years and I cannot always relate each to the person who gave them to me. If your photograph is in the book and I do not mention you, then please accept my apologies. I do have to thank Frank Washer for a large collection of slides of Wolverhampton street scenes, and Dave Clare whose remarkable efforts at photographing the inner town before so much demolition took place yielded a number of photographs from the 1970s. I believe some of the photographs have come directly or indirectly from Billy Howe's *Lost Wolverhampton*, a marvellous endeavour. Others to whom I am bound to be grateful are Ned Williams, the late Jim Boulton, Andy and Ray Simpson, Harry Blewitt, Sandra and Lewis Squires, and also myself. It's a sign of growing age when photographs you took yourself find their way into the 'then' section. I have also to thank Tim Brannon of Air Midwest at Halfpenny Green who flew me over the town to take aerial shots, and Revd David Lloyd who escorted me to the top of St Peter's to take photos at a lower altitude.